C000259972

POSTCARD HISTORY SERIES

# *Along the Perkiomen*

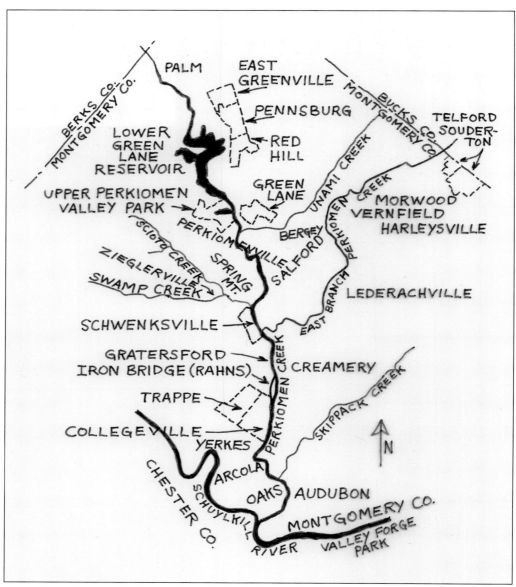

This is an author's sketch of a major portion of the Perkiomen region, as it appeared in the mid-1900s. The Main Branch of the Perkiomen Creek flows in a north-to-south direction. It begins near the northern corners of Montgomery County and empties into the Schuylkill River at the center of the county's southern boundary.

POSTCARD HISTORY SERIES

# Along the Perkiomen

Jerry A. Chiccarine

ARCADIA
PUBLISHING

Copyright © 2005 by Jerry A. Chiccarine
ISBN 978-0-7385-3809-9

Published by Arcadia Publishing
Charleston, South Carolina

Printed in the United States of America

Library of Congress Catalog Card Number: 2005922069

For all general information contact Arcadia Publishing at:
Telephone 843-853-2070
Fax 843-853-0044
E-mail sales@arcadiapublishing.com
For customer service and orders:
Toll-Free 1-888-313-2665

Visit us on the Internet at www.arcadiapublishing.com

*To my grandchildren, Brittney and Justin Chiccarine,
a new generation growing up along the Perkiomen.*

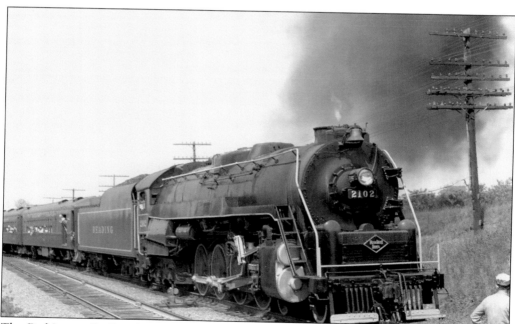

The Perkiomen Railroad generally followed the path of the beautiful Perkiomen Creek. At the dawn of the 20th century, the "Iron Horse" dominated the transportation scene in the Perkiomen Valley. With announcements made by whistle, bell, and puffing plumes of smoke, the trains visited many different towns along the way. The railroad was instrumental in accelerating growth of the region. With the proliferation of automobiles and trucks, the railroad ceased passenger service in the mid-1950s and discontinued freight services shortly thereafter.

# CONTENTS

# ACKNOWLEDGMENTS

My postcard collection began years ago when I started to buy old cards from my hometown area. The images reminded me of the good times growing up in Collegeville in the 1940s and 1950s. Later, the collection expanded to include all of the Perkiomen Valley. I began to share my collection with my family and friends, and most recently, with the *Collegeville Way*, a local newspaper. I am grateful to reader Judy Muche for prodding me to write this book. I had contemplated it previously, but without her encouragement, it may not have happened.

I am especially grateful to my wife, JoAnn, who has accompanied me to auctions, flea markets, and shows. She was patient and methodical in digging out postcards of interest. In addition, she provided the needed moral support and encouragement as the book developed. A special thanks goes to Roy Miller, who graciously allowed me to use selected postcards from his collection. Roy is quite knowledgeable about the history of the Perkiomen Valley and has generously answered my inquiries. Others who provided assistance include the following: Jennifer Rothenberger; Lee Stevenson; Myrna Knaide of the Historical Society of Trappe, Collegeville, and Perkiomen Valley; and postcard dealers Harold and Grace Burton.

Finally, this book would not exist in its current form if it were not for information compiled by the Historical Society of Montgomery County. The data contained in the archives of the society was of great value in telling the story of many postcard views.

# INTRODUCTION

In recent years, modern man, using his highly developed technology, has sent space vehicles to far-away planets in search of evidence of water. It is a universally understood principle that without water, there can be no life. Similarly, the original visitors to the place we now call Pennsylvania were in search of the life-giving waters of this land. Archaeologists tell us that the original American Indians reached this area sometime between 12,000 and 18,000 years ago. It is here that they discovered the waters of the Perkiomen Creek. These American Indians called themselves Lenni Lenape (pronounced Len-ne Le-nah-pay), which means "the Real People." When the European settlers arrived in southern Pennsylvania more than 400 years ago, the Lenni Lenape were cultivating the fertile lands around the waters of the Perkiomen. The early settlers, who were mostly of German origin, lived peacefully with the Lenni Lenape. The settlers built farms and mills along the rivers, creeks, and streams. As time went by, however, the Lenni Lenape began to move out of the area, and by 1737, they had mainly left the Perkiomen region.

Areas grew up around the many mills, farms, and early industries along the Perkiomen Creek. While transportation was difficult, the mills and farms prospered due to the ready markets in nearby cities, such as Philadelphia. Slowly, turnpikes were built and bridges constructed. A classic example was the six-arch stone bridge built in 1799 at what is now Collegeville. These bridges, along with roads such as the Perkiomen and Sumneytown Turnpike (now Route 29), did much to foster growth along the Perkiomen.

The valley and surrounding areas continued to prosper, but it was the coming of the railroad in 1868 that became the most important factor in development. The Perkiomen Railroad Company had a plan to join the Philadelphia and Reading Railroad tracks at the mouth of the Perkiomen Creek, near the Schuylkill River. The plan was to run the tracks north to Allentown. The path of the railroad was to follow the Perkiomen Creek. At its peak, four trains ran daily between Allentown and connections to Philadelphia. All along the Perkiomen Railroad line, houses were built around train stations, and villages grew with the increased commerce. The railroad carried both freight and passengers, but passenger revenues for the company never reached those generated by freight. The towns along the way, however, benefited from both. Tourism began to flourish, and by the early 1900s, many towns along the Perkiomen became favorite country retreats for the city folk.

This Postcard History Series book details the Perkiomen region in Montgomery County, Pennsylvania, as it existed generally during the first half of the 20th century. We will take a visual journey north, up the Perkiomen Creek, by way of vintage postcards. Since the railroad

runs along the creek for the most part, we will be visiting nearby towns and train stations as well. This path will begin in the region where the Perkiomen Creek empties into the Schuylkill River. The first chapter covers the areas of Oaks, Audubon, Arcola, and Yerkes. We will end our journey at the northwestern tip of Montgomery County, near East Greenville and Palm. Because of the area covered, and the scope of this book, it is not possible to achieve a comprehensive visual history of the stops along the way. Rather, this book is intended to be a "glimpse" or taste of the Perkiomen Valley. There are far too many postcards to include all of them. In addition, there are certain areas for which a postcard does not exist or has not yet been discovered by the author.

The sketches at the chapter headings were drafted by the author and are not intended for use as maps. Their purpose is to give the reader an idea of the relative proximity of the places covered. The time frame for the sketches is roughly the middle of the 20th century. In the late 1950s, the tracks had not yet been torn up following the demise of the railroad. Also, the Lower Green Lane Reservoir had just been completed. A majority of the postcards and graphics displayed in this book are from the first half of the 20th century, with a few from the later period. Please enjoy this vintage visual journey, *Along the Perkiomen*.

# One

# OAKS, AUDUBON, ARCOLA, AND YERKES

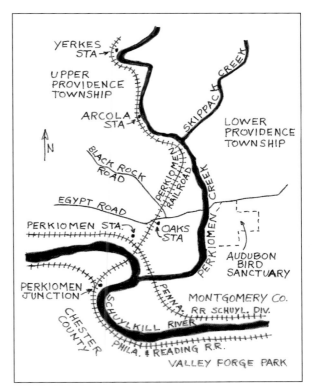

The mouth of the Perkiomen Creek is located on the Schuylkill River at the lower border of Montgomery County. Before entering the Schuylkill River, the Perkiomen separates the Upper and Lower Providence Townships. A large tributary, the Skippack Creek, joins the Perkiomen Creek from the Lower Providence side. It was the Upper Providence side of the creek that invited early development due to a more level terrain. The Perkiomen Railroad Company chose this path on the west side of the creek for its journey northward.

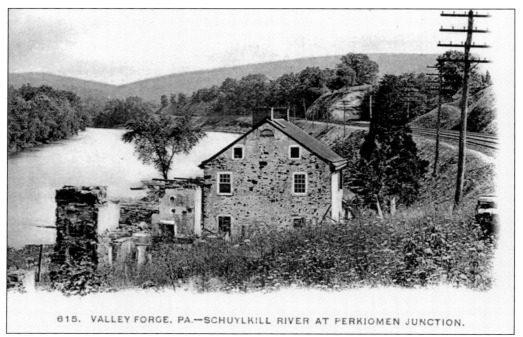

615. VALLEY FORGE, PA.—SCHUYLKILL RIVER AT PERKIOMEN JUNCTION.

At the most southern portion of the Perkiomen region, the Perkiomen Creek flows into the Schuylkill River between Oaks and Audubon. Valley Forge is located just southeast of this point. Nearby, the Philadelphia and Reading Railroad runs parallel to the Schuylkill River. At a spot adjacent to the mouth of the Perkiomen Creek, the Philadelphia and Reading had its junction with the Perkiomen line.

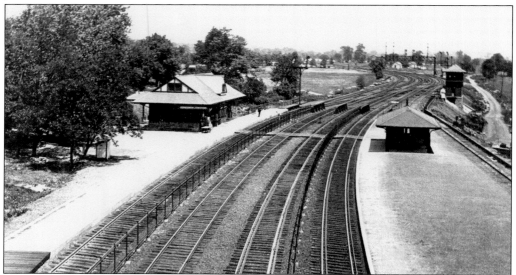

Some plans for a railroad in the Perkiomen Valley date back to 1832. Not much happened until 1865, when the Reading Railroad Company acquired a portion of the stock of an already existing corporation. The name was changed to the Perkiomen Railroad Company, and the first 10 miles were opened, from Perkiomen Junction to a point near Collegeville. In this early view, we see the Perkiomen Junction depot and its track system.

*Schuylkill River at Brower's Locks, near Oaks, Pa.*

The Schuylkill canal system was completed from upstate Pennsylvania to Philadelphia in 1830. It was an important transportation network until around 1920. Canal traffic ran parallel to the Schuylkill River until the canal crossed the river near the mouth of the Perkiomen Creek. In this *c.* 1908 view, we see the "Schuylkill River at Brower's Locks, near Oaks, Pa."

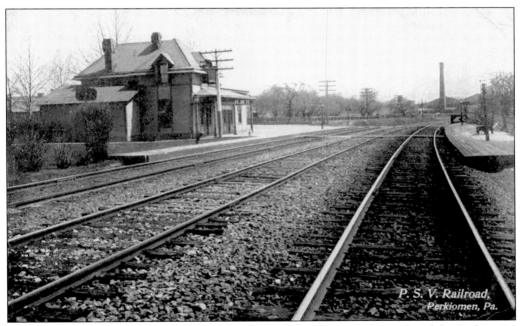

*P. S. V. Railroad, Perkiomen, Pa.*

In 1884, the Pennsylvania Railroad's Schuylkill Division crossed the tracks of the Perkiomen Railroad on its way from Norristown to Mont Clare. The Perkiomen station, shown around 1908, was located along this east-to-west line in Oaks, near a brickworks.

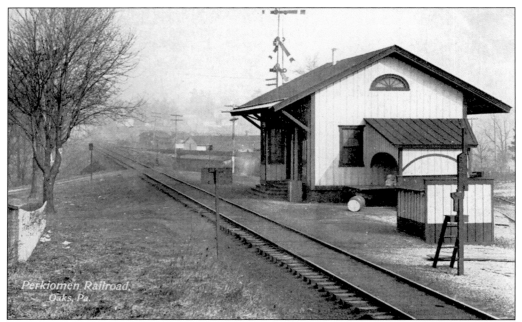

The Perkiomen Railroad Company established a station at Oaks in 1868. A cluster of homes and industries then formed around it. The first station building was located on the north side of Egypt Road, but it burned down on January 18, 1872. This view reveals the *c.* 1918 station. As of early 2005, this building still stands, although vacant.

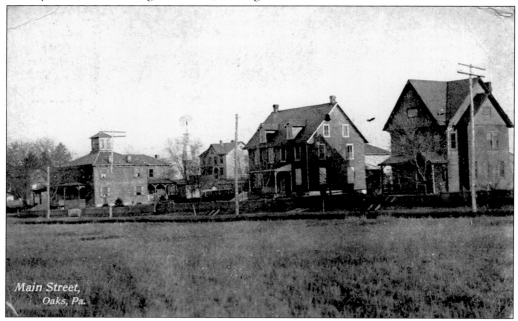

Main Street in Oaks was one of the busiest streets around town. The street was also known as Egypt Road, and this particular scene was a short distance from the railroad station. The three buildings featured in this *c.* 1908 view still remain, across the street from the present-day post office. Trees and other obstructions have since altered the view.

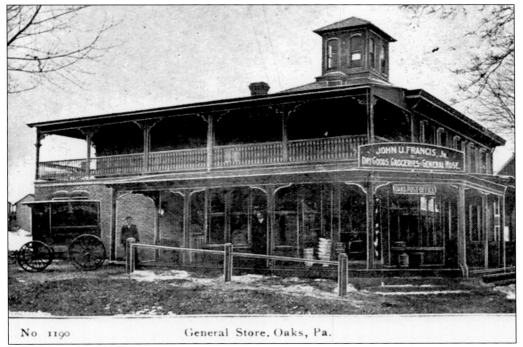

No 1190         General Store, Oaks, Pa.

In this *c.* 1905 winter scene, we see the "General Store, Oaks, Pa." The gentleman standing next to the wagon is likely John U. Francis Jr., the proprietor. Besides selling all kinds of merchandise, Francis published souvenir postcards of local views, including many of those shown in this chapter.

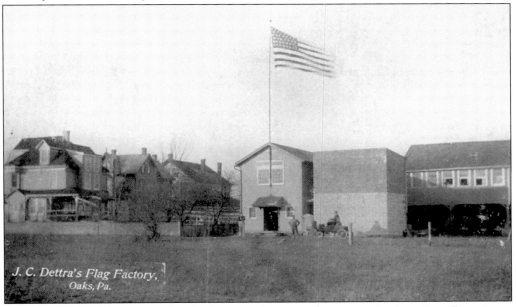

*J. C. Dettra's Flag Factory,*
*Oaks, Pa.*

In 1901, John Dettra converted a chicken coop into a business to make American flags. Large orders from companies that used flags as premiums caused the business to grow. In 1910, Dettra completed this modern plant in Oaks. He remained active in the company until his death in 1967. The company later provided the first flag to fly on the moon.

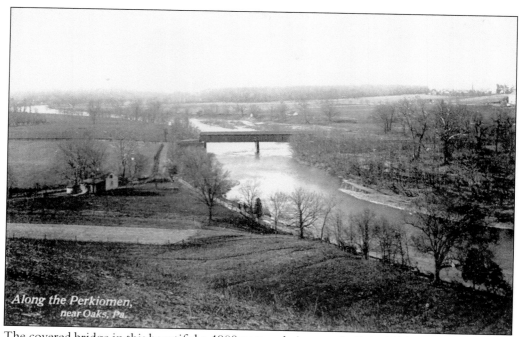

*Along the Perkiomen, near Oaks, Pa.*

The covered bridge in this beautiful *c.* 1909 postcard view was built in 1833. At the time, there were many covered bridges throughout Pennsylvania. This one was built near a place along the Perkiomen known as Vanderslice's Ford. The bridge served for almost a century before it was removed in 1931.

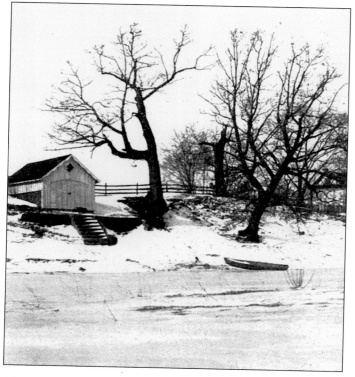

This snowy scene on the Perkiomen Creek near Oaks would provide perfect inspiration for an artist's brush. The postcard, depicting a frozen boat dock and shed, was mailed in 1909. The winter theme was used infrequently, since publishers usually had fair-weather tourists in mind for the marketing of their postal cards.

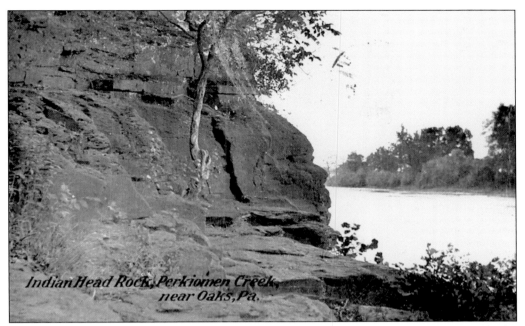

This *c.* 1913 postcard is entitled "Indian Head Rock, Perkiomen Creek, near Oaks, Pa." The striking image of an American Indian profile in this rock led to its naming; a park and several roads in the area are named after the rock as well. The formation is located on the Lower Providence side of the creek, and is difficult to access due to steep cliffs.

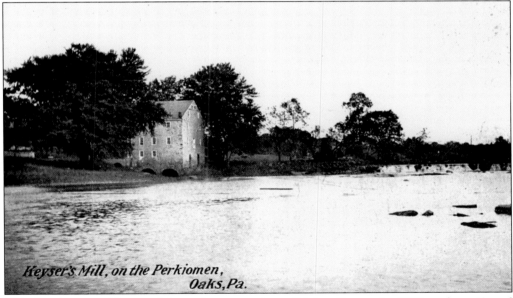

This handsome mill passed into the ownership of John Keyser in 1869 and continued operating through three generations of the family. In the early 1900s, under the ownership of W. M. Keyser, the mill advertised locally as a "miller and dealer in flour, feed, and grain of all kinds." It was sold to Indian Head Park in 1918.

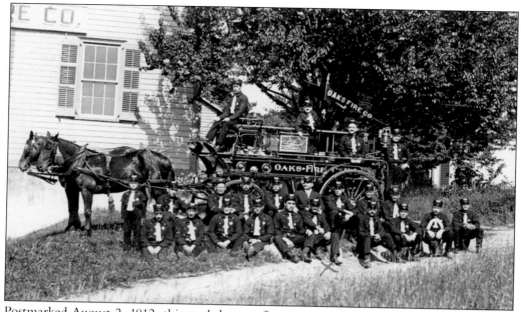

Postmarked August 2, 1912, this card shows a fire wagon that was purchased in 1910 by the Oaks Fire Company. William Keyser served as an early driver. Keyser worked for his father in the family coal and feed company on Egypt Road, across from the firehouse. When the fire bell sounded, the Keyser team of horses was hooked up to the wagon.

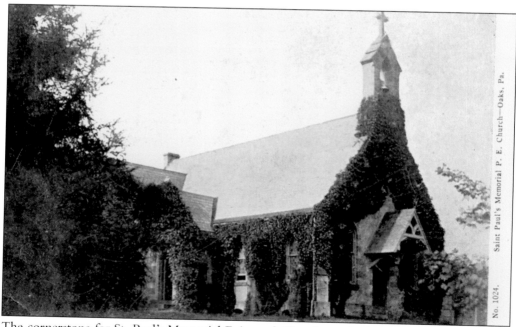

The cornerstone for St. Paul's Memorial Episcopal Church was laid September 20, 1871. The church was built as a memorial to Rev. Dr. James May, who was the rector from 1861 to 1869. The reverend had sacrificed his life ministering to hospitalized, typhus-ridden Civil War soldiers in Philadelphia.

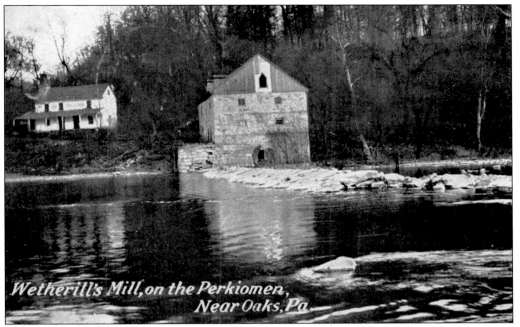

*Wetherill's Mill, on the Perkiomen, Near Oaks, Pa.*

In 1813, Mill Grove Plantation was purchased by Samuel Wetherill because of the existing lead and copper mines discovered there. The mill wheel not only provided power for the gristmill, but also transmitted power to shafts for the lead mine. Some historians report this site as the first copper mine in the country.

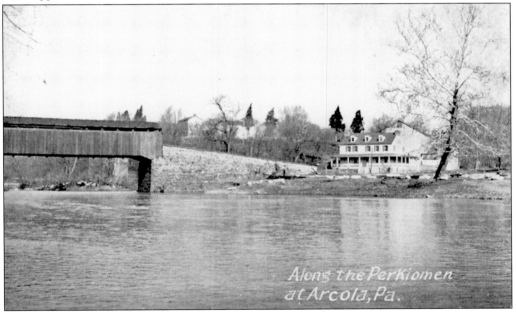

*Along the Perkiomen at Arcola, Pa.*

The covered bridge at Arcola, built in 1869, was designed in a plain Warren truss without reinforcement by sprung arches. Various groups argued about the strength and durability of the bridge. Around 1888, it was reinforced with steel flats at either end of the truss; the bridge carried the required daily loads safely till the day of its demolition in 1931.

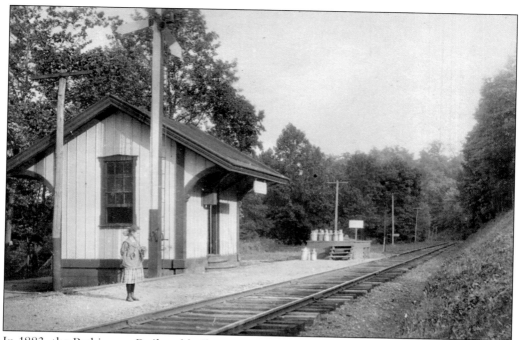

In 1883, the Perkiomen Railroad built a passenger shelter and freight platform at Arcola. The station, formerly called Doe Run, had a coal yard and mill located on the Lower Providence side of the creek. In this *c.* 1909 view, a young girl and a group of milk cans await the train. (Courtesy of Roy Miller.)

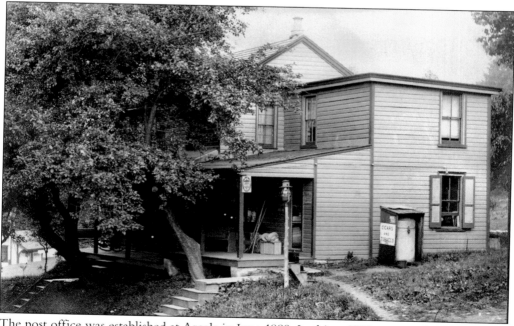

The post office was established at Arcola in June 1889. In this *c.* 1908 scene is the Arcola Store and Post Office, which though small, sold all sorts of items. It was strategically located quite near the rail station, which can be seen at the lower left. (Courtesy of Roy Miller.)

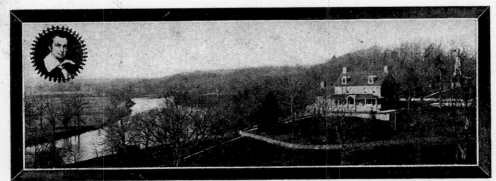

Mill-Grove-Farm-on-the-Perkiomen-Creek.　First Home in America of John James Audubon.

## Audubon, Pa.

John James Audubon was a resident of Mill Grove in Lower Providence Township for almost three years at the dawn of the 19th century. There, he developed his studies of nature while exploring his surroundings along the Perkiomen Creek. Audubon hunted and accumulated wildlife with the intent of capturing their images in works of art. He specialized in painting watercolors of native birds. His work is unrivaled to this day. Above is an early private mailing card from around 1905 that includes an image of Audubon as a young man. Also shown is the mansion in relationship to the creek. Below is the rear portion of the mansion, which was built in 1762. Mill Grove is now a public museum containing exhibits related to the life and times of John James Audubon.

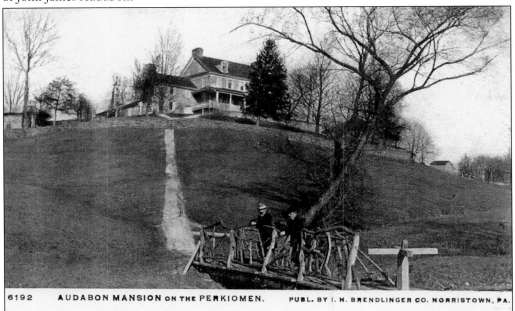

6192　　AUDABON MANSION ON THE PERKIOMEN.　　PUBL. BY I. H. BRENDLINGER CO. NORRISTOWN, PA.

19

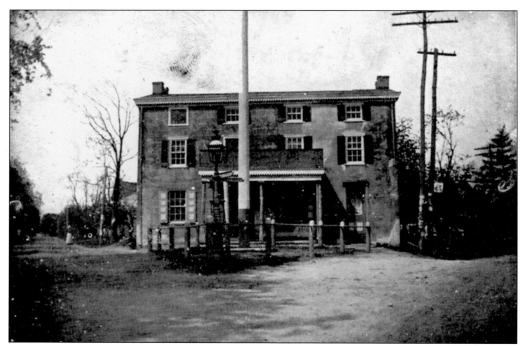

This card was mailed from the Audubon Post Office on August 3, 1909, about 10 years after the Shannonville Post Office changed its name to Audubon. The Audubon Store, seen here, also served as the post office for a number of years. It was located at the corner of Egypt and Pawlings Roads but was razed some years ago.

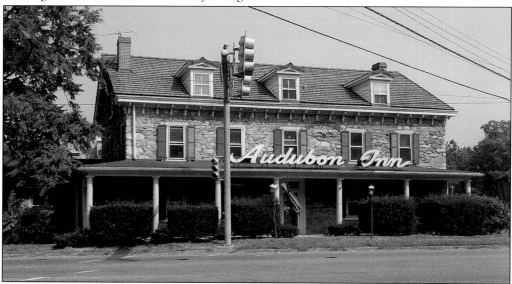

The Audubon Inn, shown here in a recent photograph, is located at Egypt Road and Park Avenue. When the structure was built, around 1757, it was part of a farm; afterward, it became Shannon's Inn. In 2004, the inn came into jeopardy of being demolished. However, the building was spared when Lower Providence Township swiftly drafted an ordinance that would preserve all historic structures in the township.

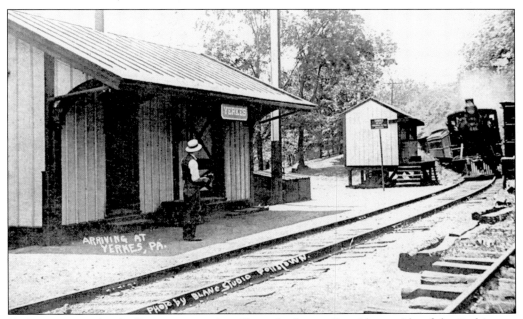

Yerkes was a station built to serve a gristmill on the Lower Providence side of the Perkiomen Creek. The passenger and freight depot was constructed around 1881. In this classic *c.* 1920 postcard, a steam locomotive is "Arriving at Yerkes, Pa."

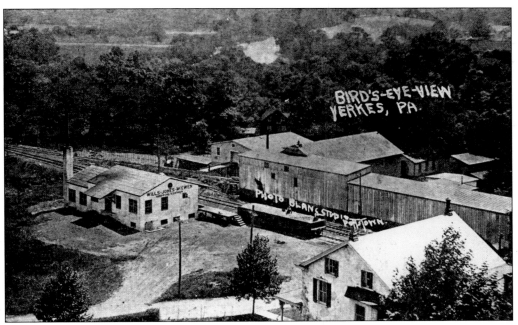

The village of Yerkes was named for Isaac Yerkes, owner of the land on which the railroad station was established. This *c.* 1920 "Bird's-eye-view, Yerkes, Pa." is a partial view of the village, just north of the rail station. Though small, Yerkes was an active area in handling and shipping farm and mill products. (Courtesy of Roy Miller.)

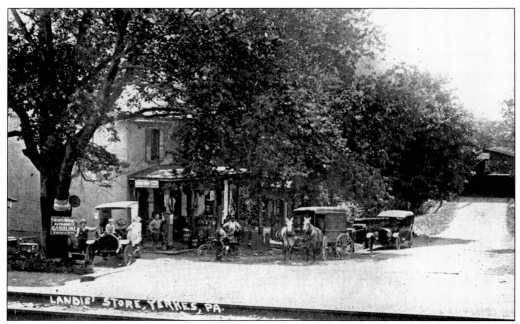

Yerkes was located near a flour and gristmill on the Perkiomen Creek. The Landis Store was near the end of the bridge at the mill dam. Postmarked July 5, 1921, this card shows the store, which sold general merchandise, including feed, grain, coal, and gasoline. (Courtesy of Roy Miller.)

Steep banks running from Arcola to the Yerkes area on the Lower Providence side of the Perkiomen Creek prevented much organized shore activity. Fishermen, however, preferred the undisturbed settings, and Yerkes still managed to attract a small share of the tourist trade in the 1920s.

# *Two*

# COLLEGEVILLE
# AND TRAPPE

At the turn into the 20th century, Lower Providence Township was almost completely farmland. Even until 1980, many properties in Evansburg had a small barn that originally stabled a horse or two. Early settlements grew more quickly on the Upper Providence side of the Perkiomen Creek. The village of Perkiomen Bridge became Collegeville after 1868, when the railroad named its station and settled a controversy between the names Perkiomen Bridge and Freeland. The separate but adjoining boroughs of Collegeville and Trappe were formed in 1896.

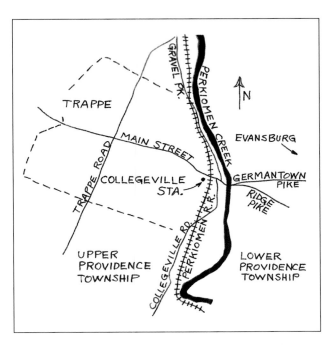

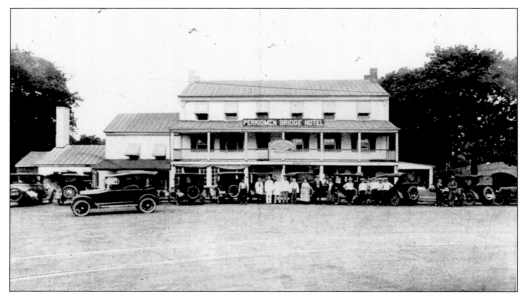

Advertised as the oldest hotel in the country, the Perkiomen Bridge Hotel in Collegeville dates back to before 1701, when it was a stagecoach stop on the route between Philadelphia and Reading. Throughout the 18th and early 19th centuries, the hotel was an important stop for merchant travelers seeking lodging and food. After the Perkiomen Railroad Company came through the area, the hotel was a significant tourist destination.

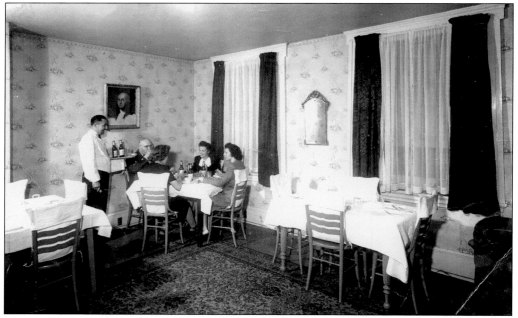

The Perkiomen Bridge Hotel was located in an area that was crossed on several occasions by Revolutionary troops at the founding of our nation. It is not surprising that historians have reported that Gen. George Washington dined in the hotel's parlor. This c. 1946 photograph, taken by the author's parents, shows the room in which Washington dined. A portrait of our first president adorned the wall at that time.

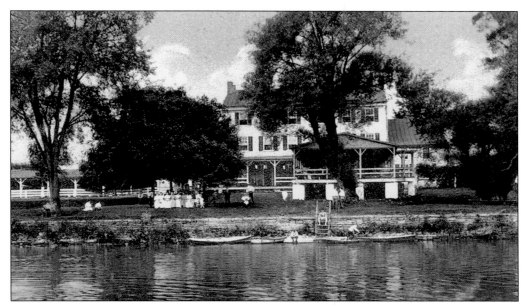

This *c.* 1909 postcard view is entitled "Perkiomen Bridge Hotel Lawn, Collegeville, Pa." It shows the hotel with its porches, extended pavilion, lawn, and beautiful shade trees. Boat docks were located behind the hotel, as well as along both sides of the Perkiomen Creek. Visitors came for a day, or a week, or more to avail themselves of the activities, which included boating, swimming, fishing, dancing, and traveling to local attractions.

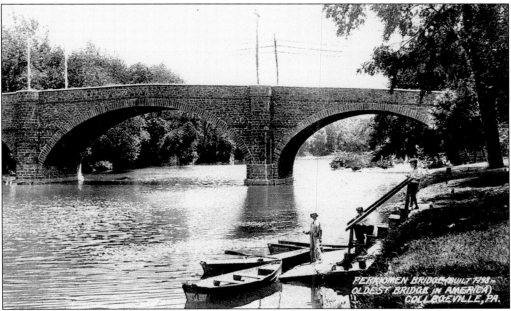

The Perkiomen Bridge at Collegeville is one of the oldest stone bridges in the country. Construction on this historic structure was supported by a lottery and was completed in 1799. In 1928, the bridge was widened by a total of 15 feet by removing the entire north side and rebuilding it using the same facing stone. This early view, from around 1909, shows the north side before it was widened.

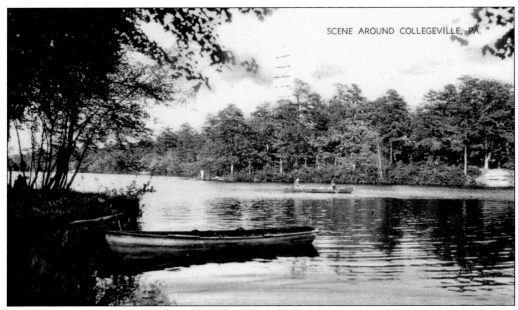

The above view, entitled "Scene around Collegeville, Pa.," is just one of literally hundreds of similar water scenes produced along the towns bordering the Perkiomen Creek. The tranquility and beauty captured in these postcards was used by the publishers to lure visitors to the Perkiomen Valley. During the early part of the 20th century, boating and all kinds of aquatic activities were especially satisfying. One reason for this was that many dams were still in place from the days of the mill activities along the creek. The dams produced deep, slow-moving water that was perfect for boating, swimming, and fishing. Below is an image of the Mill Dam as it appeared around 1906. The dam was within the Collegeville municipal limits, at the northeastern portion of the borough. The Mill Dam originally served to feed the raceway for a roller flour mill. In recent memory, locals called this spot "the Nook." In September 2003, the dam was removed to preclude spending additional funds for maintenance.

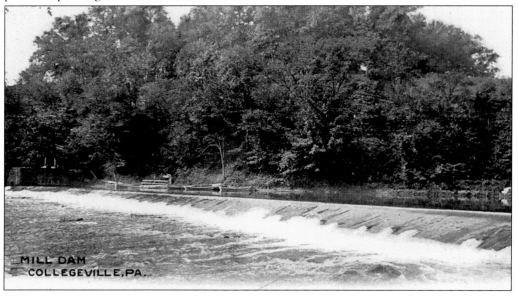

MILL DAM
COLLEGEVILLE, PA.

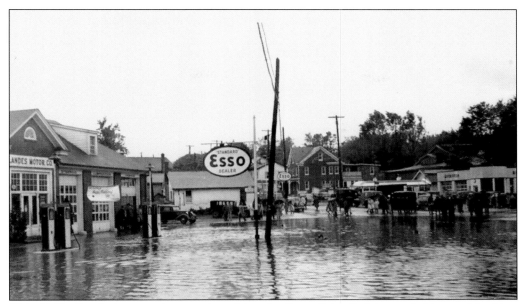

This 1940s flood photograph was taken from the foot of the Perkiomen bridge and looking west on Main Street. Most of these buildings have been razed over time, and the Landes Motor Company, at left, is now the home of the Keyser Miller Ford Company. Since the construction of the dam at Green Lane in the 1950s, flooding has been less serious.

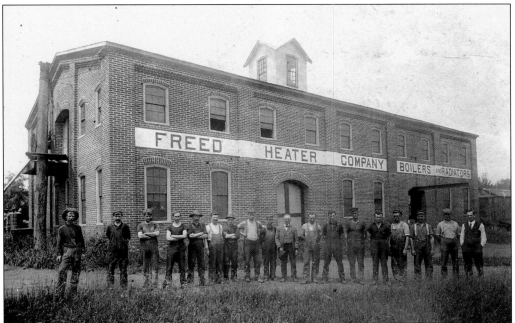

In 1906, the Freed Heater Company acquired the former Roberts Machine Shop located at Third Avenue and Walnut Street in Collegeville. The Freed Company continued operating here until a fire completely destroyed its plant in 1940. The fire also caused losses to the Collegeville Flag Company, which had been leasing the west end of the building. The fire consumed $13,000 worth of Halloween costumes.

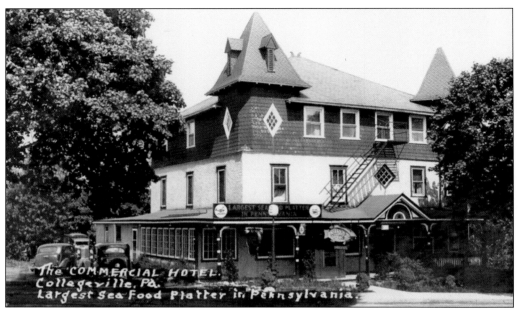

In the 1940s, the Commercial Hotel advertised "the largest sea food platter in Pennsylvania." Located diagonally across the street from the Collegeville railroad station, the hotel was a popular place to stay for summer tourists and local boarders. The building has had various additions and face-lifts since that time. It is now the home of Harpoon Louie's Restaurant, another purveyor of fine seafood meals.

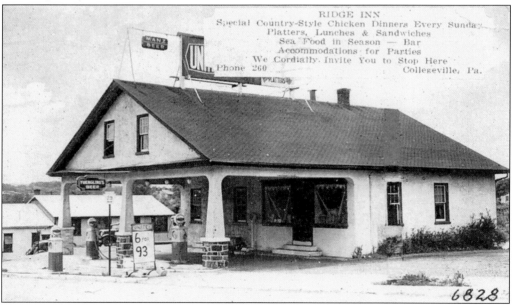

The Ridge Inn restaurant and gas station was located on Main Street next to the railroad station on the east side. The business advertised its country-style chicken dinners offered every Sunday, platters, lunches and sandwiches, seafood in season, and a bar. According to the sign out front in this c. 1940 card, the gas station was running a special on gas, at six gallons for 93¢. Those days are gone, and so is the Ridge Inn.

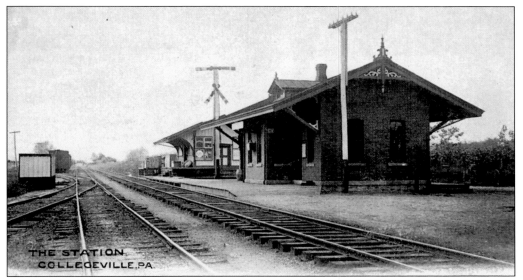

In 1868, the first 10 miles of the Perkiomen Railroad tracks were laid. The tracks reached as far as Skippack station, which was a distance past Collegeville. The original station at Collegeville was a wooden structure. Around 1895, this fine brick Victorian structure was built. After the end of the railroad era, the station was razed, and the site became the location of various businesses. Currently, it is home to the Collegeville Diner.

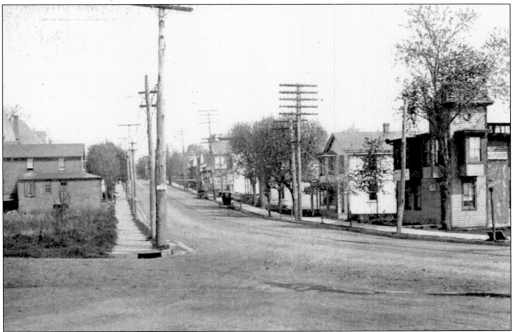

In this *c.* 1906 view, two buggies are parked on Main Street between Third and Fourth Avenues. Judging from the shadows, this photograph was likely taken during a busy morning of shopping at the local market, which was located in the middle of the block. The building at far right, with the tower, was the home of the *Independent* newspaper. The newspaper and building had originated in Trappe and were relocated around 1883.

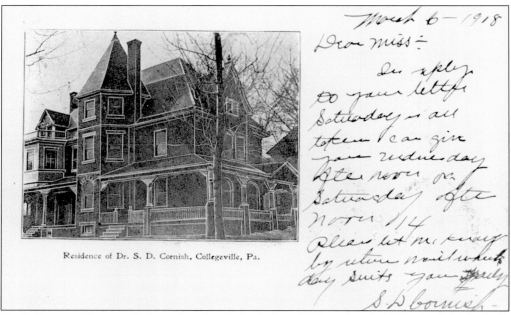

Residence of Dr. S. D. Cornish, Collegeville, Pa.

March 6 — 1918
Dear miss :—
In reply to your letter Saturday is all taken I can give you Wednesday after noon or Saturday aft noon 14 Please let me know by return mail which day suits you truly
S. D. Cornish —

Dr. S. D. Cornish was a Collegeville dentist in the late 1800s and early 1900s. In 1894, he built the stately Victorian home shown here. In this correspondence, sent on March 6, 1908, Cornish is trying to arrange an appointment with Delila Glasser of Zieglerville. The following year, Cornish started the Collegeville Flag Company with two employees. The business made aprons as well as flags. Later, the company added Halloween costumes to its line.

This graphic is from the box top of an early Halloween costume manufactured by the Collegeville Costume Company, a division of the Collegeville Flag Company. By the middle of the 20th century, the business had grown to the point that it was one of the most significant employers in the borough. The company occupied several buildings in the area between Third and Fourth Avenues. Costumes were marketed and sold far and wide, making the name "Collegeville" a familiar one to kids and parents in all parts of the country.

This was the first Catholic church building erected in Collegeville. In 1921, the basement-type structure was built on Main Street with the thought of adding an additional story in the future. It was constructed to accommodate 20 permanent local families as well as vacationers. The idea of expanding the original building was later abandoned, and in 1971, the parish built a new, much larger church on Locust Street. In June 2004, the parish had a total of 3,697 families.

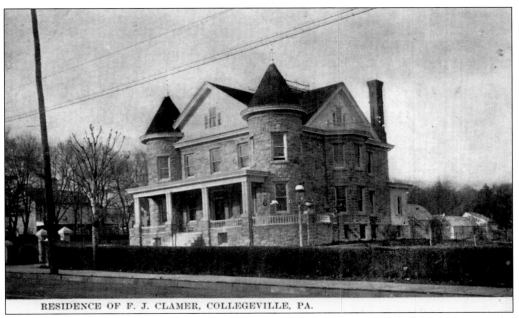

RESIDENCE OF F. J. CLAMER, COLLEGEVILLE, PA.

F. J. Clamer was responsible for starting the Ajax Metal Company of Philadelphia, known the world over for bronze metal hardware. In 1903, he built this mansion at Fourth Avenue and Main Street in Collegeville using native stone. Clamer served several terms as burgess of the borough and also was a trustee of Ursinus College. (Courtesy of Roy Miller.)

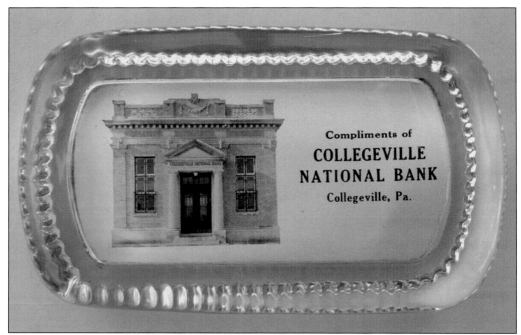

This paperweight was used as an early advertising item for the Collegeville National Bank. When the bank first opened its doors, in 1907, total deposits were $24,767.67, and customers earned three percent interest on their deposits. The building's façade was given a contemporary look in the 1950s. The bank is currently operated as Harleysville National Bank and Trust Company.

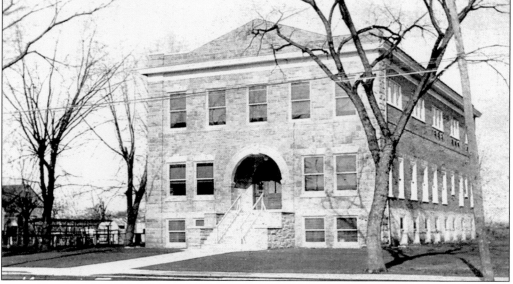

Warren Lodge No. 310 is one of the old and worthy institutions in Collegeville. This stately Masonic lodge building has stood on Main Street since its cornerstone was laid on May 31, 1913. The lodge was first chartered in 1857, and the group met temporarily in various locations before this building was completed.

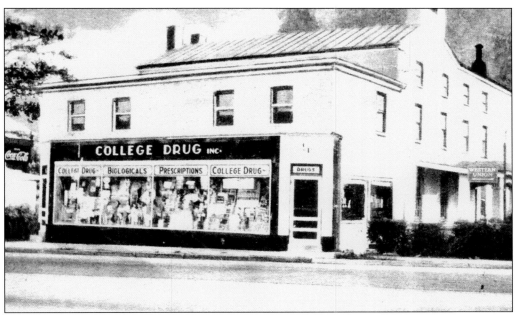

This card, showing the College Drugstore, was postmarked July 26, 1938. During the first half of the 20th century, the store was run by the Winkler family and later by the Lutzes. The store sold all kinds of medicines, miscellaneous small novelties, and house supplies. In addition, the author well remembers the classic 1950s soda fountain in the store. In recent years, it has been home to Marzella's Pizzeria.

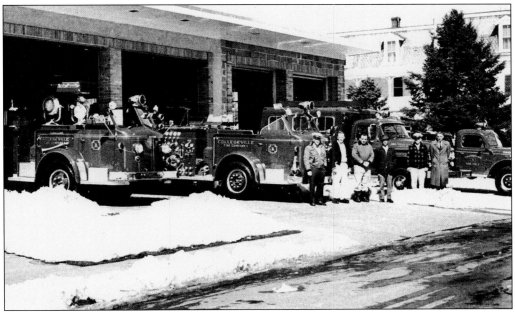

The equipment and personnel of the Collegeville Fire Company are revealed in this snowy, late-1950s view. The company was originally organized in 1891 as a result of a spectacular fire that nearly destroyed the adjoining businesses of the Roberts Machine Company and the Collegeville Ice Manufacturing Company.

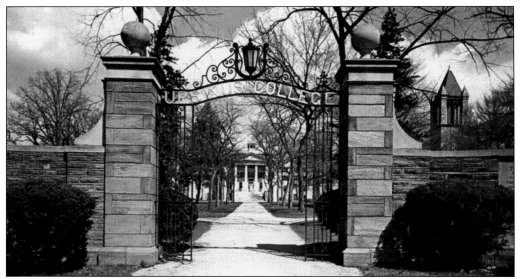

This mid-1900s postcard highlights the Eger Gateway to Ursinus College. This Sixth Avenue entrance to the campus originally led to Freeland Hall, which is the building centered in the gates in this view. Freeland Hall was one of the oldest buildings on the campus until it was razed to make room for the Myrin Library in 1970.

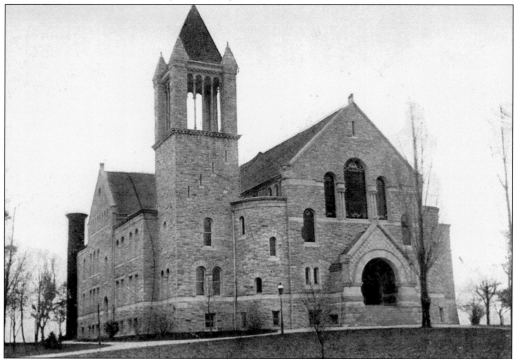

Bomberger Hall was named for John Henry Augustus Bomberger, the first president of Ursinus College. Begun in 1891, it was the first structure expressly built for the college. The façade was designed in a Romanesque style and was constructed of local Pennsylvania blue marble. This exterior has changed little over the years, but in 2004, the college embarked on a renovation of the interior.

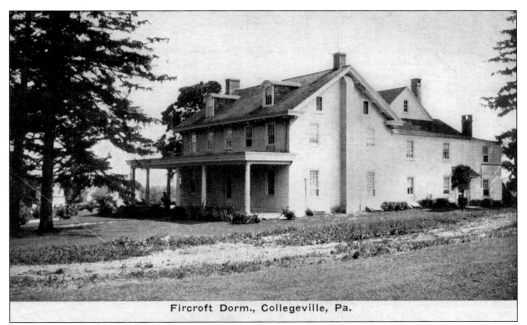

Fircroft Dorm., Collegeville, Pa.

In this *c.* 1920 view, we see the "Fircroft Dorm., Collegeville, Pa." The female dormitory was donated to Ursinus College by Sara E. Ermold in honor of her mother. Still standing at Tenth Avenue and Main Street, this building is one of the oldest along Main. It had originally been constructed in 1835 by the prominent Hunsicker family as a private residence.

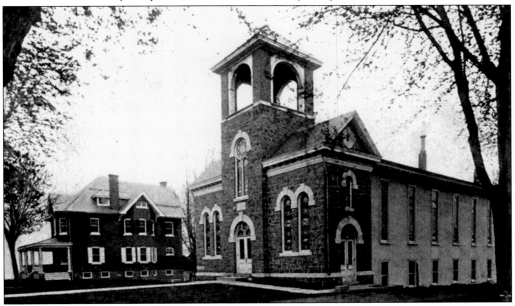

Abraham Hunsicker, along with others, organized the Christian Society of Montgomery County in Freeland in 1854. The first society building was erected in 1855. The building, the name of the church, and the town have changed over the years. In this *c.* 1908 view, we see the "Trinity Ref'd Church and Parsonage, Collegeville, Pa." Today, the church looks much the same, but the parsonage building has been removed.

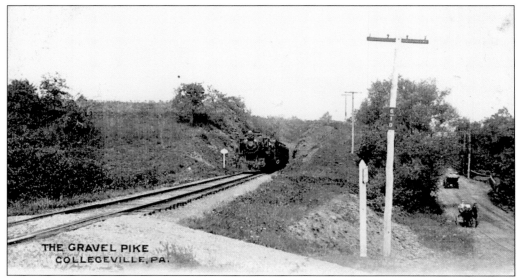

This *c.* 1906 postcard shows the yet unpaved Gravel Pike and the rail bed of the Perkiomen Railroad Company. Heading south down the tracks on its way to the Collegeville station is a steam locomotive. On the right, two other modes of transportation can be seen on Gravel Pike: a vintage automobile is going north, while a horse buggy is coming south.

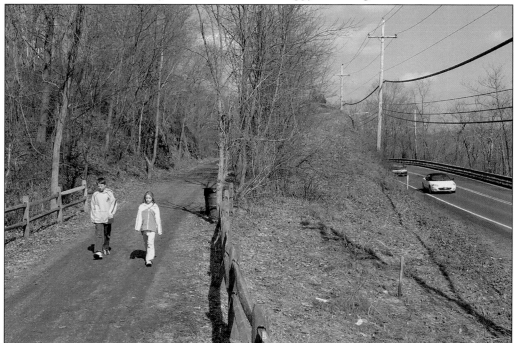

In this recent photograph, taken at about the same location as the above postcard view, Gravel Pike has been widened and paved. At left, the old bed of the rail line is now the popular Perkiomen Trail. Through the wise planning of the Montgomery County commissioners, the trail was completed in 2003. For the most part, it follows the route of the old Perkiomen Railroad and currently runs from Oaks to Green Lane.

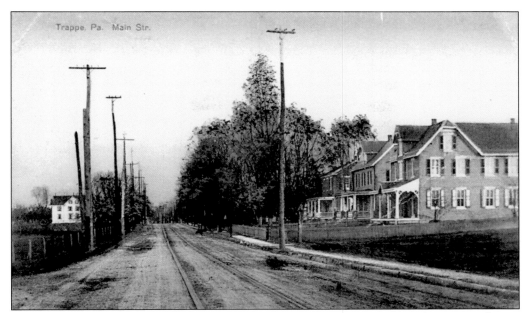

This card was postmarked and sent from Trappe on August 16, 1909. It provides a view of Main Street at a time when the tracks of the Schuylkill Valley Traction Company ran down the center of the street. This view faces east, but the tracks also extended westward. People were able to travel by trolley, with connections, from places as far away as Philadelphia and Pottstown.

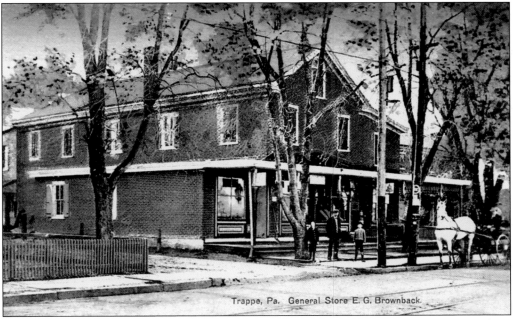

In 1895, E. G. Brownback purchased the mercantile business at 538 Main Street in Trappe from his father–in–law, John K. Beaver. The general store continued to be successful and remained in operation for many years. Subsequent to its closing, at least 10 different businesses operated at the location, until 1967. In that year, it became Peck's Television Service, which continues to operate as Peck's Electronics.

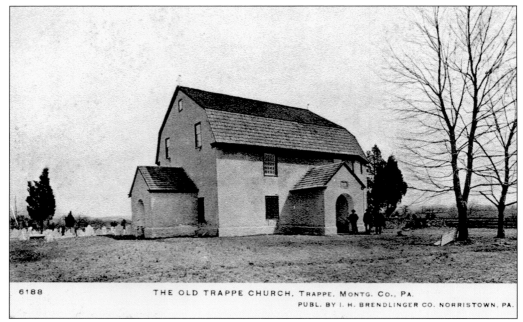

6188            THE OLD TRAPPE CHURCH, TRAPPE, MONTG. CO., PA.

PUBL. BY I. H. BRENDLINGER CO. NORRISTOWN, PA.

The Augustus Lutheran Church in Trappe is the oldest unaltered Lutheran church in the country. Built in 1743 by Pastor Henry M. Muhlenburg, the church represents a German rural architecture and was said to be 54 "shoes" long by 39 "shoes" wide. The congregation built a new, larger church near the original one in 1852. Both historic buildings still stand.

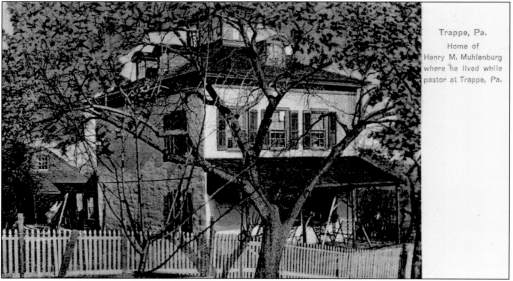

Trappe, Pa.

Home of
Henry M. Muhlenburg
where he lived while
pastor at Trappe, Pa.

In 1745, Pastor Henry M. Muhlenburg, with the help of his father-in-law, built his first home in Trappe. The lot adjoining the church property originally contained 33 acres. The house was the birthplace of 8 of the pastor's 11 children. The building was remolded in 1851 and is seen here around 1908. It still stands a short distance northeast of the old church.

38

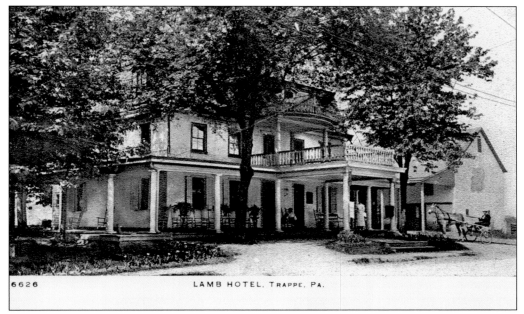

6626        LAMB HOTEL, TRAPPE, PA.

The Lamb Hotel, at 724 Main Street in Trappe, was built between 1800 and 1802. It is believed that the large mansard-roofed section at the front was added in the 1880s, when S. W. Gross was proprietor. The Mingo Express Horse Company for the Apprehension and Return of Stolen Horses was organized in 1836, and at one time, the group met regularly at the Lamb Hotel. The old building remains, although significantly remodeled.

St. Luke's United Church of Christ of Trappe was founded in 1742. In 1874, St. Luke's built a new stone church on the west side of Main Street, several hundred feet south of the site of the congregation's first two church buildings. The cemetery is still in use at the original location. In this early-1900s postcard view, the newly installed front stone wall has replaced an iron fence.

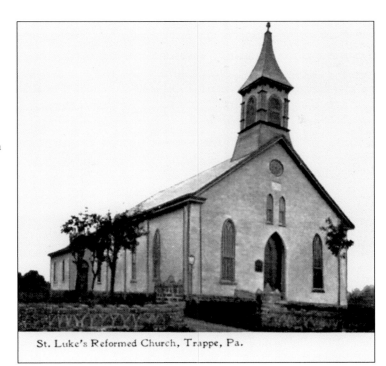

St. Luke's Reformed Church, Trappe, Pa.

39

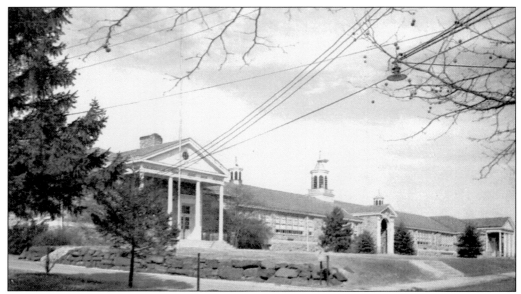

The Collegeville-Trappe High School is seen in this mid–20th-century view. The joint school district was formed in 1938. In June 1939, approval was obtained for the building of a high school on First Avenue in Trappe. Construction was performed under a Public Works Administration (PWA) project. When the school was occupied, Howard B. Keyser served as principal, and he continued in that position for many years.

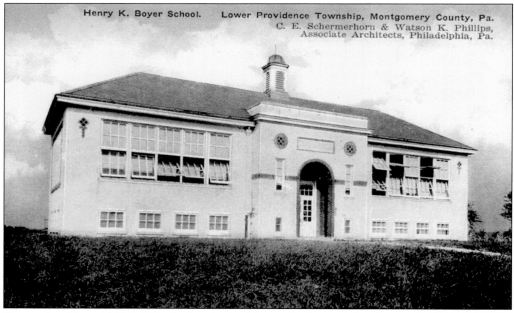

Shown in this *c.* 1918 postcard view is the Henry K. Boyer School on Evansburg Road in Lower Providence Township. The school dates to 1916 and was built to replace two older township schools. Four classrooms were added in 1952, and the school remained in service until 1975. The building still stands and has recently been the home of several businesses and a childcare center.

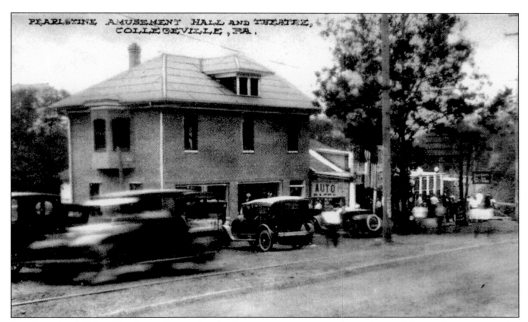

During the 1920s, Abraham Pearlstine had an amusement center and rental bungalow properties along Ridge Pike and the Perkiomen Creek in Lower Providence Township. In this busy postcard scene, we see that the buildings also included a theater. In the mid–1900s, the structures were razed, and the colorful Swiss-style Collegville Inn was constructed on the site.

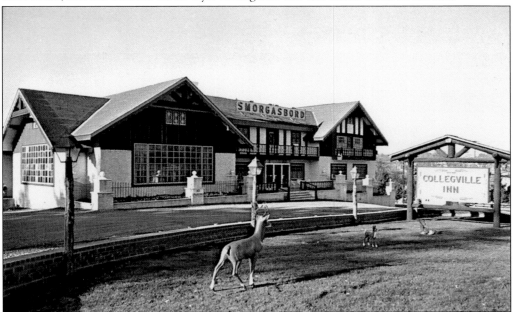

The old Collegville Inn was famous "the world over" for its smorgasbord-type meals. Note that the name "Collegville" was purposely misspelled to avoid a legal challenge, since the restaurant was actually located in Lower Providence and not Collegeville. For decades, it did a brisk business under the proprietorship of the Hahn family. Several years ago, the building was remodeled to an Adirondack style. The inn is still serving meals today.

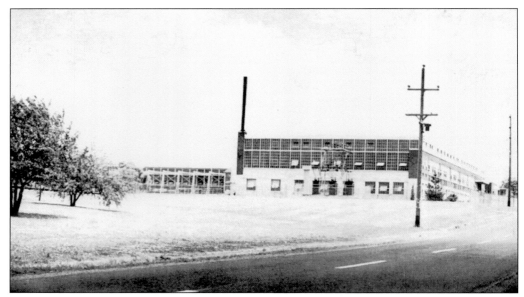

The Superior Tube Company was incorporated in 1934, and soon thereafter occupied an old aircraft engine testing facility on Germantown Pike in Evansburg. Since that time, Superior Tube has been a world leader in the production of small–diameter metal tubing. The company produces a wide spectrum of tubes for such uses as hypodermic needles, military aircraft, and aerospace technology. This is an early postcard view of the company's facilities.

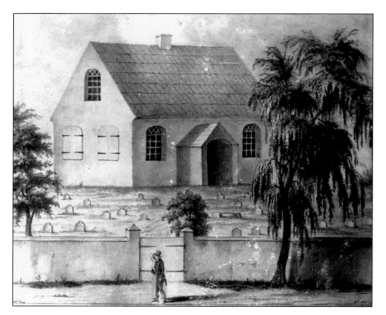

St. James Church in Evansburg was originally chartered as the St. James Episcopal Church of Perkiomen. The first building was erected in 1721 on the north side of what is now Germantown Pike. The present church building, erected on the other side of the pike, dates to 1843. This early postcard view depicts the schoolhouse that was erected in the 1780s. Until recent times, it had been home to the Evansburg Free Library.

# *Three*

# IRONBRIDGE/RAHNS, CREAMERY, AND GRATERFORD

In 1702 Mathias Van Bebber purchased land from William Penn. In 1886, portions of that land were divided and became Perkiomen and Skippack Townships. Skippack Township was heavily agricultural and was dominated by Mennonites. In 1927, the establishment of the Eastern State Penitentiary removed 1,800 acres from private use. At the turn of the 20th century, the villages of Ironbridge, Graterford, and Creamery were all thriving. Their services and products were sought by many local and urban communities. Graterford and Ironbridge benefited from the tourist trade generated by the railroad.

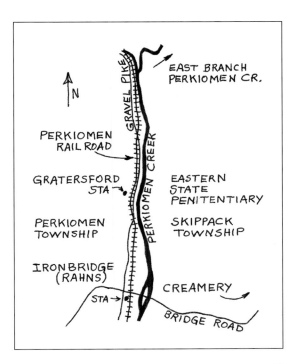

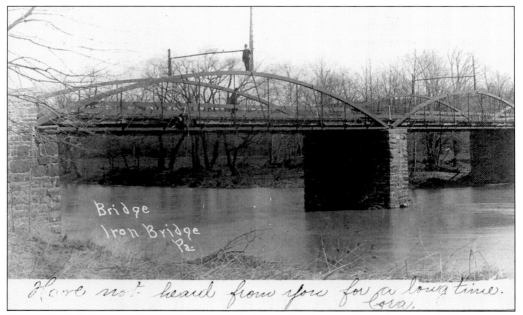

Postmarked February 28, 1907, this card shows the iron bridge that was built over the Perkiomen Creek at Rahns in 1873. The bridge became famous due to its span of 644 feet, plus its innovative use of steel girders. When the post office was established in 1880, the village became known as Ironbridge. In 1923, when the bridge collapsed into the creek, the name of the village reverted back to Rahns.

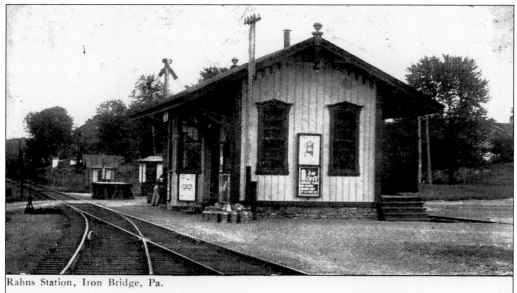

Rahns Station, Iron Bridge, Pa.

The above card, postmarked from the Ironbridge Post Office on July 5, 1909, reveals the north side of the Rahns station of the Perkiomen Railroad Company. The station maintained the name of Rahns even after the name of the village had been changed to Ironbridge. When the railroad sought right-of-way through his property, George Rawn gave free title to the land, but he stipulated that the depot always be called "Rahns."

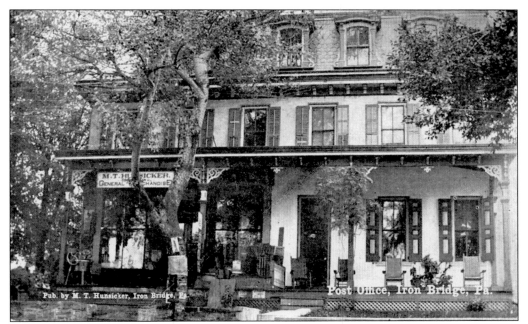

Pub. by M. T. Hunsicker, Iron Bridge, Pa.

Post Office, Iron Bridge, Pa.

Like many of his relatives in the area, Melvin T. Hunsicker was a practical, energetic, and successful merchant and postmaster. He owned several stores, including the one in Ironbridge at the northwest corner of Gravel Pike and Bridge Street. The store and post office carried a large stock of merchandise for farmers and the general population. Although much changed, the building still stands and is used as private residences.

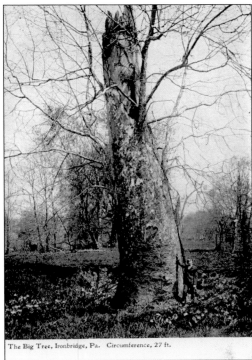

The Big Tree, Ironbridge, Pa.  Circumference, 27 ft.

A sycamore tree measuring almost nine feet in diameter grew on an island in the Perkiomen Creek near the bridge at Ironbridge. No doubt the waters surrounding the island contributed to the astounding growth of the tree, believed to be the biggest in the county. This *c.* 1906 view shows a portion of the island that was a favorite picnic spot for Sunday schools, fire companies, and other groups because the water was shallow and safe for children.

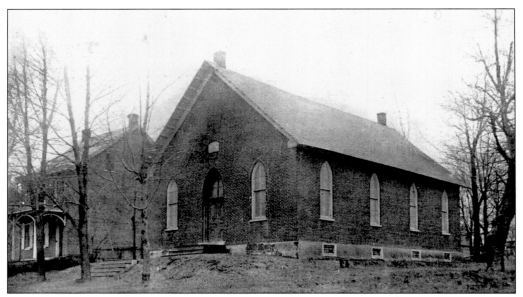

Located on Centennial Street in Ironbridge, the Union Chapel was built in 1882. The brick Gothic Revival structure had been used for services by the Trinity Reformed Church, as well as other Christian denominations. In 1926, after the town name was changed, the church was rededicated as the Rahns Chapel. In 1973, the building became a private residence, and it still stands after significant attractive modifications.

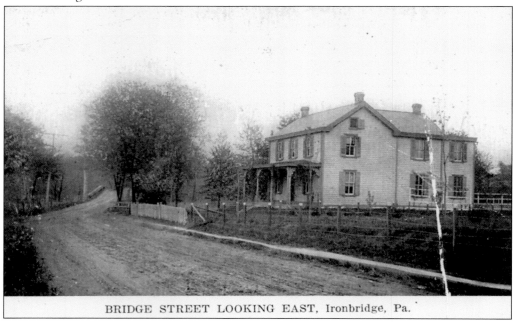

BRIDGE STREET LOOKING EAST, Ironbridge, Pa.

By the early 1900s, Ironbridge had become a flourishing country resort village. While hotel facilities were limited, nearly every home took in boarders. A typical house is seen in this *c.* 1915 postcard, entitled "Bridge Street Looking East, Ironbridge, Pa." The accommodations were ample if not luxurious. This particular residence remains standing today, and has been changed only slightly on the exterior.

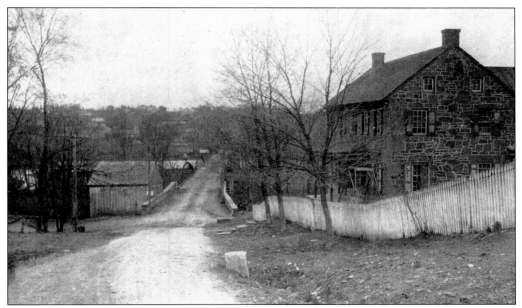

This "Scene in Ironbridge, Pa." looks west on Bridge Street from the Skippack Township side of the Perkiomen Creek. Straight ahead is the iron bridge for which the village was named. Postmarked August 21, 1922, this card was sent just one year before the bridge collapsed into the creek. The building on the right has been expanded and is the present-day Gypsy Rose Restaurant. (Courtesy of Roy Miller.)

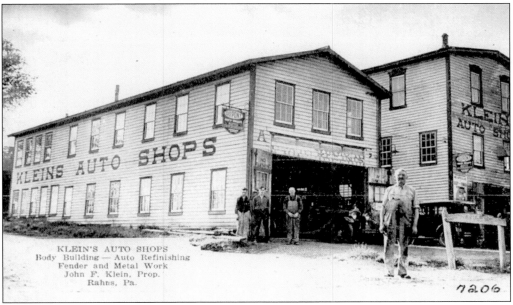

John F. Klein was a carriage builder in Ironbridge at the dawn of the 20th century. By 1910, it had become clear that the horse carriage was about to be replaced by the horsepower generated by the automobile. Klein converted his business to service this new contraption. Seen in this c. 1920s view, his shops performed all kinds of bodywork and metalwork in the village now called Rahns.

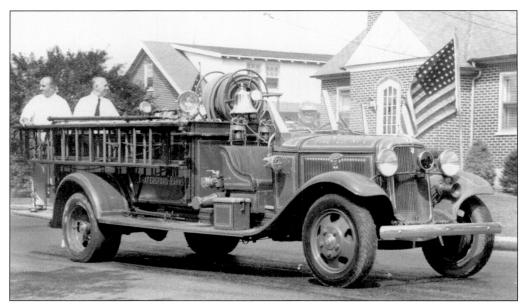

Until 1951, the neighboring fire companies of Schwenksville and Skippack provided protection to Perkiomen Township. The 1934 Ford truck seen here was the first piece of equipment owned by the Perkiomen Fire Company No. 1. In 1963, this original truck was sold and is now preserved in the Henry Ford Museum in Dearborn, Michigan. (Courtesy of Roy Miller.)

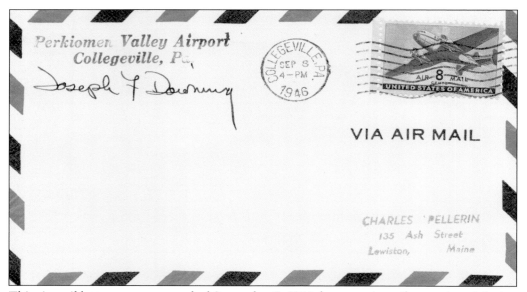

This air mail letter cover, postmarked September 8, 1946, bears an air mail stamp issued during World War II, on March 21, 1944. The return address on the envelope is that of the Perkiomen Valley Airport, located in Skippack Township. Started by Wells McCormick in 1938, the airport facility comprised 57 acres with a 3,000-foot hard-surface runway. It is currently continuing its operations.

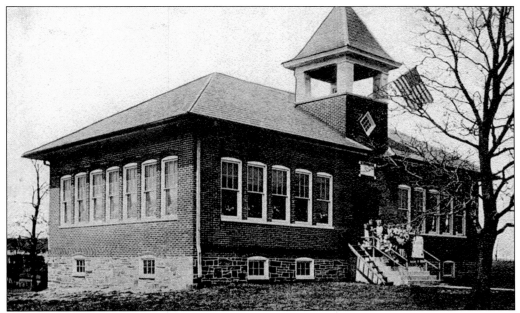

This sturdy stone and brick schoolhouse was built in 1913 on Bridge Road in Creamery. In this *c.* 1920 view, students stand on the front steps, below the flag flying from the bell tower. The bell tower has since been removed, and the building has been expanded greatly. It is now the home of the local 4-H Club.

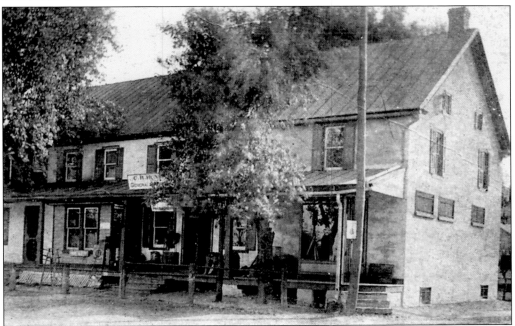

The Creamery general store and post office had been in the Bean family for more than 100 years when a son-in-law took over in 1898. C. R. Hunsicker operated the business until 1926. In 1975, the post office was moved a short distance from the store. The former general store still stands at the sharp "S" curve on Bridge Road, but had operated as an appliance service store in recent years.

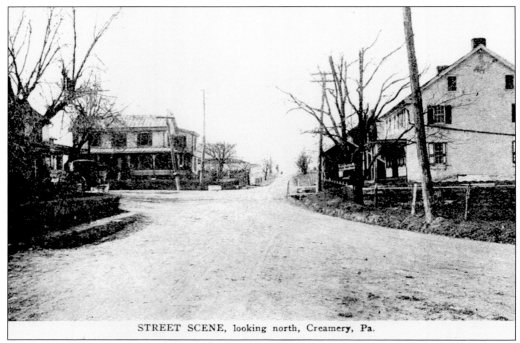

STREET SCENE, looking north, Creamery, Pa.

Creamery is a small community located at this sharp "S" curve on Bridge Road. The area was originally known as Harmony Square. In 1880, when the post office was established, officials learned that there was already another post office with that name. Therefore, postmaster John Bean chose the name "Creamery" for the postal designation.

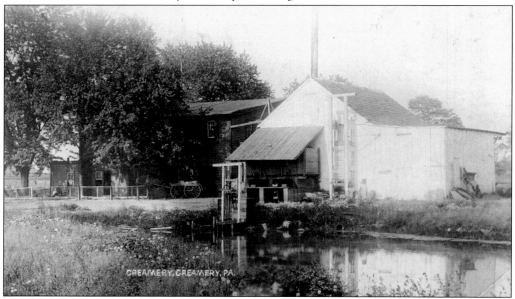

CREAMERY, CREAMERY, PA

In this *c.* 1910 postcard view, we see the creamery that gave the area its name. It was the main industry in the village at that time. The first cooperative creamery in Pennsylvania, it survived until the 1930s. Its demise was due, in part, to the loss of dairy farms when the Graterford Penitentiary acquired a large amount of land in Skippack Township. (Courtesy of Roy Miller.)

50

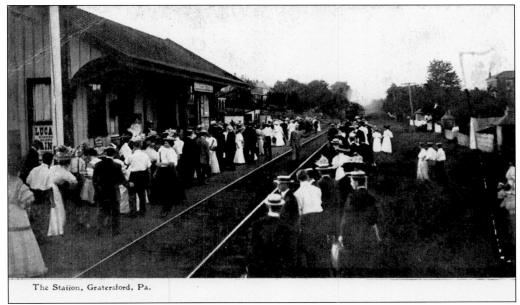

The Station, Gratersford, Pa.

This postcard gives an indication of the crowds that came through the Graterford station during the early 1900s. There was a high level of activity in hauling both freight and passengers along the Perkiomen Railroad line. The passenger service was more visible and had a greater impact on local villages. Summer and weekend boarders filled hotels, boardinghouses, and even pitched tents in farm fields. In summer months, the railroad filled 12 to 14 coaches on the Sunday evening return trip to Philadelphia.

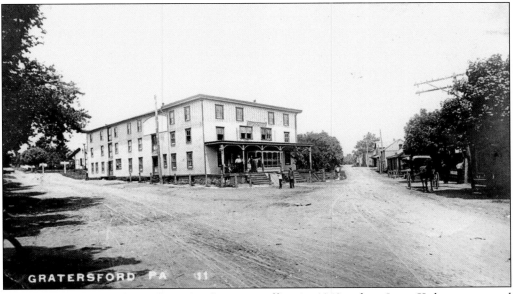

GRATERSFORD PA 11

The village of Grater's Ford got its first post office in 1869, when Isaac Kulp was named postmaster. In 1894, the post office became "Gratersford" and in 1907 "Graterford." All three spellings have been used over time. In this 1906 postcard, the post office is located in the general store of Kulp and Moyer. The store building, located at Gravel Pike and Bridge Street, burned in 1963 and was not replaced.

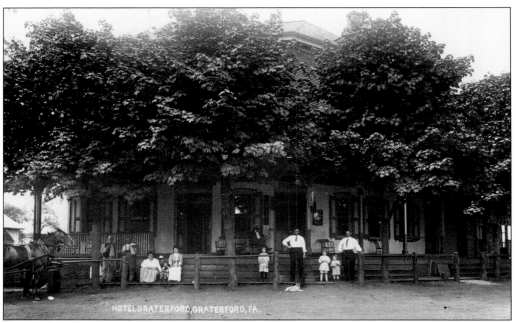

Built in 1860, the Hotel Graterford is a brick three-story structure with an unusual shape in a Gothic Revival style. The hotel's location at the center of the village allowed easy access to the railroad station, situated nearby on the northwestern side. At the time of this postcard, dated August 4, 1911, the hotel had all kinds of modern conveniences, including gas lighting, in-house baths, reading rooms, and the choicest liquors. (Courtesy of Roy Miller.)

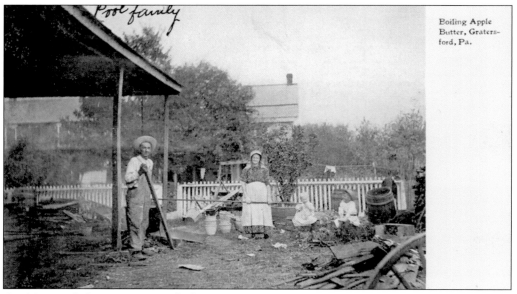

Cooking apple butter in Graterford was a common annual ritual a century ago. It was a lot of hard work, but it also provided families with enjoyable sights, smells, and flavors that only the country life could deliver. The writing on this c. 1907 postcard indicates that we are looking at a scene with the Pool family.

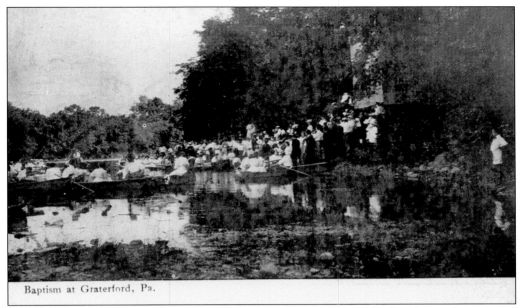

Baptism at Graterford, Pa.

A religious sect called the River Brethren or Dunkards, or sometimes simply Dunkers, settled on a strip of land south of Graterford. The group, who had a small chapel or meetinghouse in the village, believed in baptizing one another face down, three times, in a flowing stream. In this *c.* 1907 postcard, people are gathered on the Perkiomen Creek for just such a ceremony.

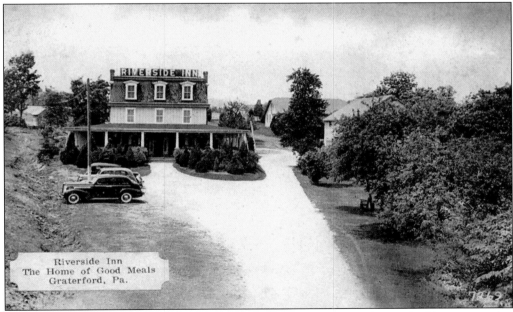

Riverside Inn
The Home of Good Meals
Graterford, Pa.

By the time this view of the Riverside Inn was taken in the 1940s, the inn had been operating for many decades. Here, the popular hotel's postcard advertisement boasts "Home of Good Meals." In 1930, the inn had reportedly fed Al Capone and his party when he was released from Graterford Penitentiary due to ill health. In the 1970s, this establishment was known as the Riverside Speakeasy. The building was removed at a later date.

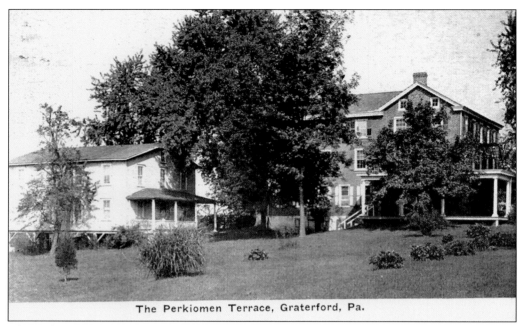

The Perkiomen Terrace, Graterford, Pa.

The Perkiomen Terrace in Graterford was a fine summer resort that had a large main house and several small bungalows. This establishment was popular with all kinds of tenants, but the proprietors seemed to advertise with an eye for attracting fishermen. During the time frame of this *c.* 1920s view, guests could rent full bedroom suites at rates of approximately $6 to $7 per week.

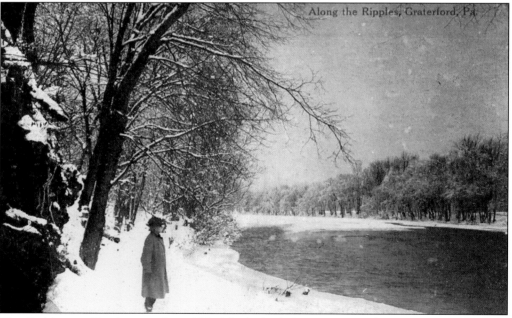

Along the Ripples, Graterford, Pa.

The Perkiomen Creek was a beautiful sight in both its summer and winter dress. With the summer cottages and boardinghouses empty, this frozen scene in Graterford (from around 1910) would be appreciated only by the local permanent residents. The penetrating quiet that accompanied this scene would only help focus the senses on the majesty at hand.

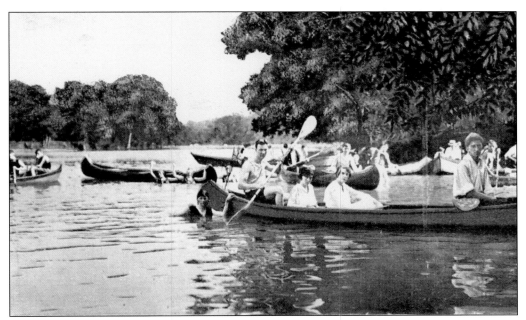

This 1928 postcard view, entitled "Boating Along the Beach at Graterford, Pa.," makes most first-time viewers chuckle. It must have been a city slicker who named this card, for surely there is no sandy shore or beach along the Perkiomen. Sent home to Twenty-fourth Avenue and Locust Street, Philadelphia, this card does show how city folks cooled off before the advent of room air-conditioning.

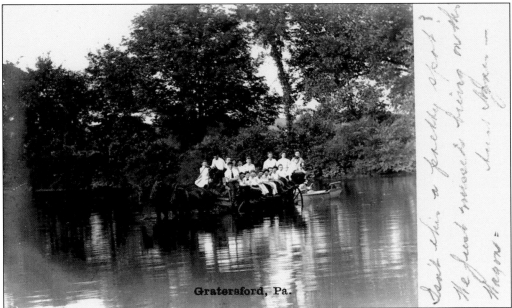

Gratersford, Pa.

Reminiscent of the name of the village, this wagon—full of vacationers—was in the process of "fording" the Perkiomen Creek at Graterford. On the back of this card, postmarked August 28, 1906, the sender writes, "Isn't this a pretty spot? We just missed being on this wagon. Aunt Agnes." Note the formal attire of the riders. My, how times have changed!

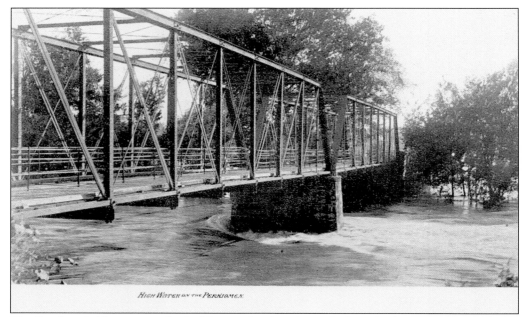

HIGH WATER ON THE PERKIOMEN

The first iron bridge to span the Perkiomen Creek at Graterford was built in 1881. It was rebuilt and improved at later dates and withstood time and high water, as shown in this *c.* 1907 postcard view. The flooding became less severe after the late 1950s, when the Green Lane reservoir and dam was built. Those improvements came just a little late for this bridge, which fell in 1956.

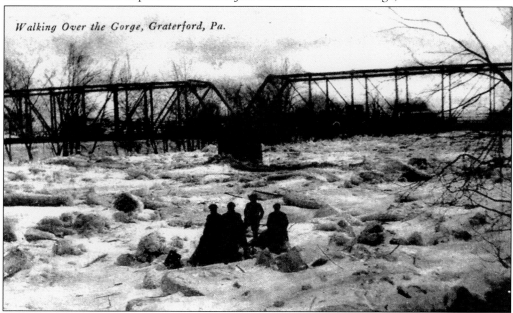

*Walking Over the Gorge, Graterford, Pa.*

Webster's Dictionary gives a secondary definition of the word "gorge" as "a chocking mass of ice." This nighttime silhouette view of the bridge on the Perkiomen, from about 1939, is appropriately titled "Walking Over the Gorge, Graterford, Pa." Nighttime views were rarely used on postcards. Equally unusual were the conditions of freezing and flooding that created this dramatic scene.

56

# Four

# THE EAST BRANCH

The East Branch is one of the many tributaries of the Perkiomen Creek. It is one of the largest ones. The southwest-bound East Branch of the Perkiomen Creek has its source in Bucks County, well beyond the Montgomery County border. For the most part, villages along the East Branch did not develop nearly as much as those along the Main Branch of the Perkiomen. This area had been largely bypassed by the railroads, except for the rail line through nearby Telford and Souderton.

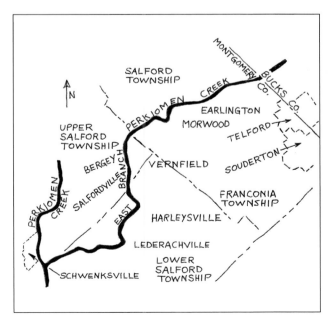

Lederach is located on the east side of a bend in the East Branch of the Perkiomen Creek. The general store of F. M. Mayberry was located along the old Skippack Pike, in the village then called Lederachville. In the early 1900s, the store also housed the post office, which was established in 1859 as Lederachsville. The name was changed to Lederach in 1907. (Courtesy of Roy Miller.)

In 1884, Lower Salford Township had 10 one-room schoolhouses. This card, postmarked April 14, 1911, shows the one located at Lederach. The first school with multiple rooms was not built until 1912. In the years before 1922, township students only attended school through the eighth grade.

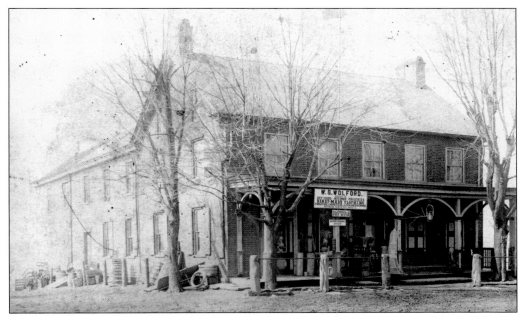

Salfordville is located about midway between the Main and East Branches of the Perkiomen Creek. When this card was sent, on September 4, 1911, W. S. Wolford was a relatively new owner of the Salfordville General Store. It had previously been run by Augustus H. Smith, the proprietor since 1856. The store, which also served as the post office, sold ready-made clothing, groceries, furniture, paints, drugs, and other miscellaneous items. (Courtesy of Roy Miller.)

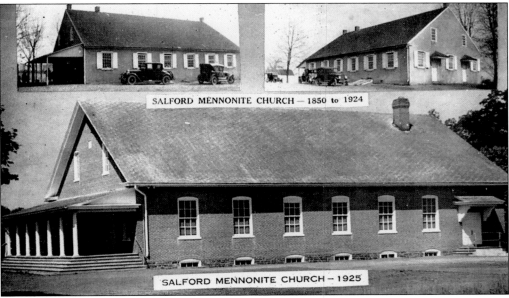

The Salford Mennonite Church was established along Groffs Mill Road, near the East Branch of the Perkiomen Creek, in Lower Salford Township. The first meetinghouse was built in 1738. Depicted on the upper portion of this postcard is the third meetinghouse, which was built in 1850 and enlarged in 1897. In 1925, the fourth meetinghouse was constructed.

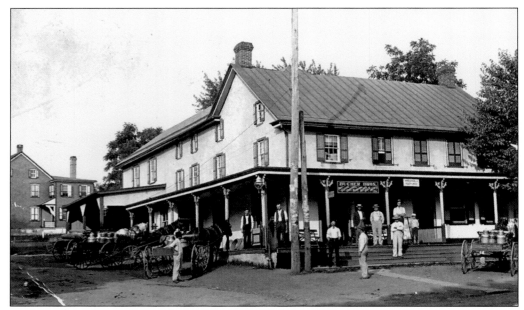

Harleysville is located near the East Branch of the Perkiomen and the West Branch of the Skippack Creek. In this *c.* 1910 view of the Bucher Brothers General Store and Harleysville Post Office, the local gentry likely awaits the arrival of mail. The sign over the entrance indicates that the store sold "Dry goods, groceries, furniture, shoes, oils, paints, etc."

Harleysville had been bypassed in the earlier developments spurred by the railroad lines in eastern Montgomery County. By the 1930s, the automobile was well established as a means of travel. Alderfer's Service Station on Main Street was set to capitalize on the motoring public's need for gasoline and services. In this scene, the gas tank and radiator are being filled simultaneously. What service!

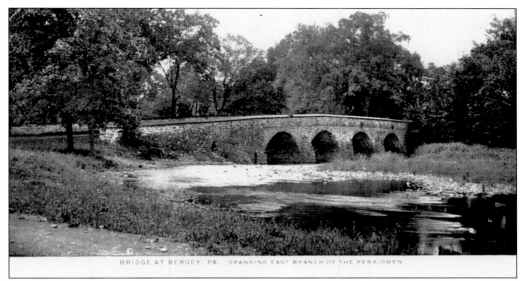

BRIDGE AT BERGEY, PA. SPANNING EAST BRANCH OF THE PERKIOMEN

Bergey, formerly known as Branchville, was located about two miles east of Salford. This *c.* 1910 postcard is titled "Bridge at Bergey, Pa. Spanning East Branch of the Perkiomen." This four-arch stone bridge was built in 1841 to replace an earlier bridge that had become dilapidated. In the early days of this span, travelers had to stop and pay a toll to cross on the Old Sumneytown Turnpike.

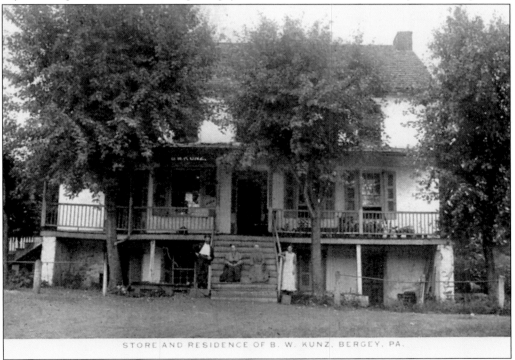

STORE AND RESIDENCE OF B. W. KUNZ, BERGEY, PA.

This *c.* 1906 postcard view shows the "Store and Residence of B. W. Kunz, Bergey, Pa." In the days of the stagecoach lines, Bergey thrived, and a small village grew up. By the time the railroad passed several miles to the west in 1874, Bergey had seen its best days. As a village, it was in a state of decline when this image was captured.

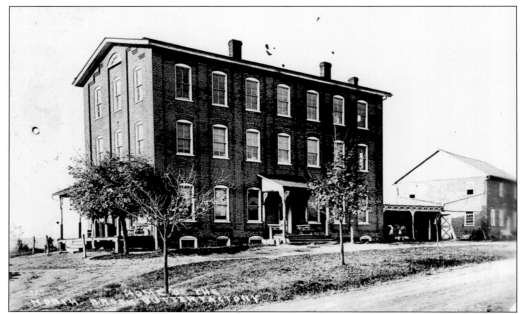

This early-20th-century card is titled "Home of the North Brook Butter Factory," just one of many businesses that operated out of this location in Vernfield. The large building was also known as the Nyce Building because the Nyce Postcard Company occupied all of the second floor. In addition to the various businesses, the site housed the Vernfield Post Office and the last general store in Montgomery County.

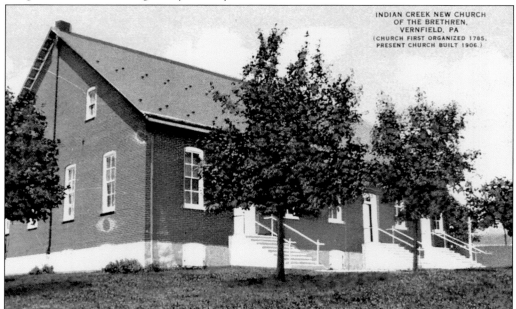

Seen here *c.* 1917, the Indian Creek New Church of the Brethren (Dunkers) was located near Vernfield. This church began as early as 1723, when members met in private homes. The congregation built its first meetinghouse in 1785 and a subsequent stone church in 1851. The old stone church was torn down in 1906, when this brick structure was built.

About 1915, William Nyce founded a printing firm on the second floor of the Vernfield General Store and Post Office. It began as a postcard factory and, in later years, expanded to greeting cards and offset and letterpress printing. In postcards, the company seemed to specialize in humorous and patriotic themes. This patriotic card is a sample of the company's flag souvenir postcards. On the back of this card, an advertisement states, "This card can be used for DECORATION DAY, FOURTH OF JULY, or any time of the year. Highly glazed, beautifully colored, with gold background. Greetings from your town printed in gold. Regular 5 cent value. We are sure you will be pleased with this series. Not less than 50 sold. Our special introductory price is 60 cents per 50, or $1.15 per 100 cards."

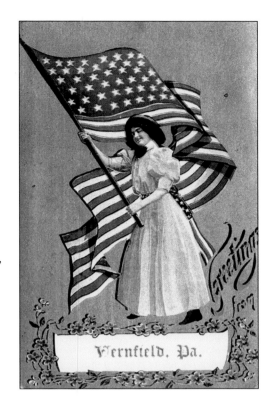

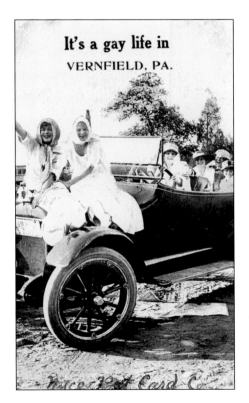

As demonstrated earlier in this book, times keep changing. This sample card, produced by the Nyce Post Card Company about 1917, is titled "It's a gay life in Vernfield, Pa." Then, this statement had quite a different meaning than the common usage of the 21st century.

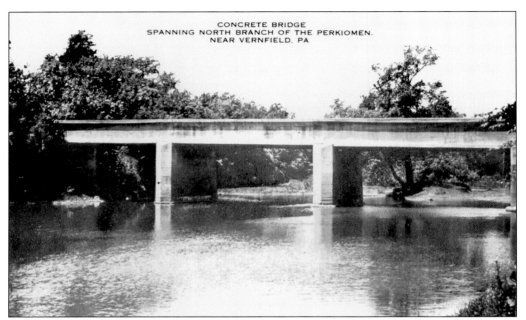

This early postcard shows the "Concrete Bridge Spanning the North Branch of the Perkiomen Near Vernfield, Pa." Though not as artistic as others, this bridge is quite noteworthy. When it was built by Montgomery County in 1900 at a cost of $4,200, it was the only all-concrete bridge in the state. The span was constructed as an experiment, and the commissioners were so pleased that concrete bridges became the standard for the future.

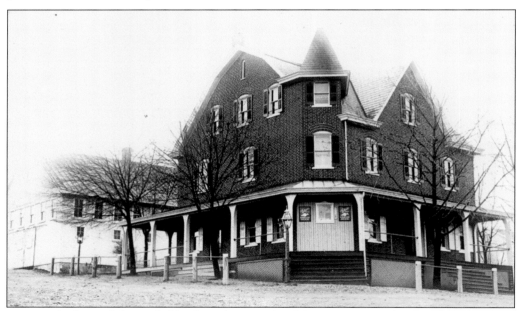

Morwood is located about a half mile to the east side of the East Branch of the Perkiomen Creek. This c. 1906 postcard view shows the Morwood Hotel. In 1895, Enos M. Godshall opened a restaurant and hotel near the junction of Keller and Morwood Roads. The establishment was a popular eating place for travelers of all kinds until it closed, shortly before 1947.

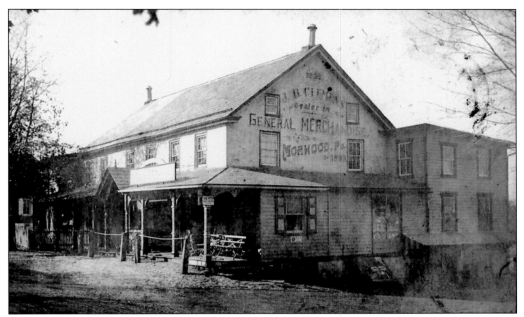

The village of Morwood first received this name on September 12, 1888. When the post office had opened in 1881, the area had been called Gehman in honor of the family that owned the general store. J. B. Clemens operated the store at the time of this 1906 postcard view. The building still stands and is now a private residence.

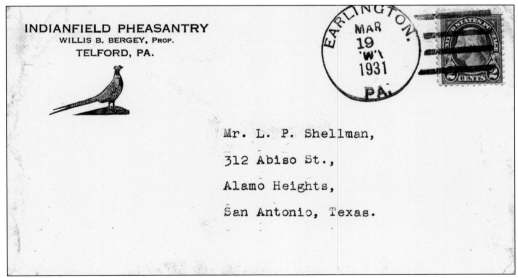

INDIANFIELD PHEASANTRY
WILLIS B. BERGEY, PROP.
TELFORD, PA.

Mr. L. P. Shellman,

312 Abiso St.,

Alamo Heights,

San Antonio, Texas.

The above letter cover was postmarked March 19, 1931, and was sent out of the Earlington Post Office. Earlington is just east of the East Branch of the Perkiomen Creek and somewhat west of Telford. The interesting return address and logo is that of a business called Indianfield Pheasantry run by Willis B. Bergey.

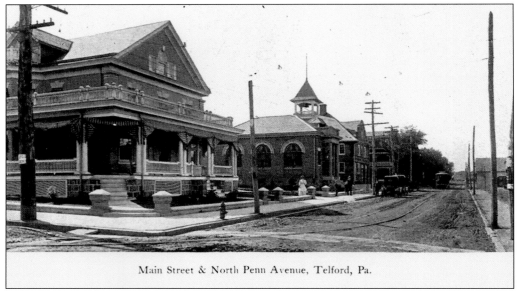

Main Street & North Penn Avenue, Telford, Pa.

The East Branch of the Perkiomen Creek enters Montgomery County from Bucks County, a short distance northwest of the contiguous boroughs of Telford and Souderton. In the early 1900s, both Telford and Souderton had excellent transportation systems. The North Penn Railroad Company served the area and allowed for a healthy marketing of goods and services with larger metropolitan areas. In addition, the Inland Traction Company and later the Lehigh Valley Transit Company operated a successful trolley line until 1951. In the early-1900s postcard view above, entitled "Main Street & North Penn Avenue, Telford, Pa.," a trolley approaches the intersection. The view below, an early-1900s look at Souderton, is titled "North End and Main Street Before Improvements." The sign on the building at right indicates that this is a carriageworks and boasts of services that include "horse shoeing and general black smithing." Note the trolley tracks down the middle of Main Street and the railroad tracks at the upper right side.

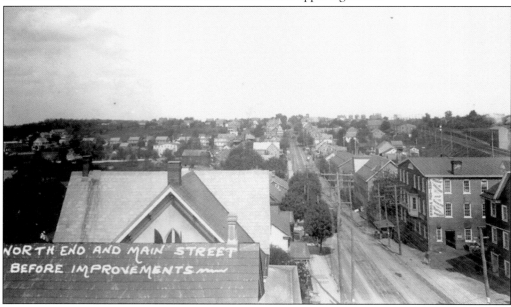

# *Five*

# SCHWENKSVILLE, SPRING MOUNT, AND ZIEGLERVILLE

At Spring Mount, the Perkiomen Creek separates the townships of Lower Frederick and Upper Salford. After flowing by Spring Mount and Delphi, the creek makes a slight westerly turn before resuming its southbound course at the north side of Schwenksville. Also, at this point above Schwenksville, the Swamp Creek flows into the Perkiomen from the west. In the early 1900s, Schwenksville played a prominent role in the growth of surrounding villages. Schwenksville became a borough in 1903.

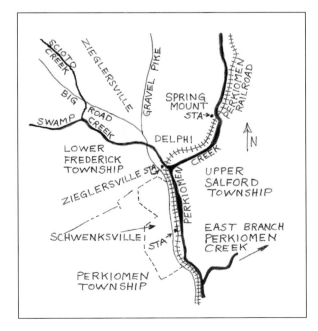

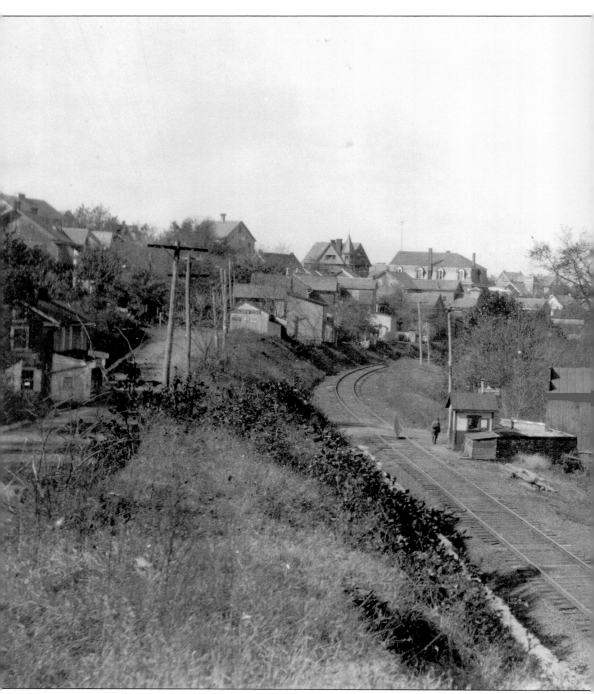

This rare bird's-eye view of the south end of Schwenksville was captured on film at the dawn of the 20th century. At the far left, the toll house on Gravel Pike is in operation, with the gate in the down position. This road dates back to 1846, when the Perkiomen and Sumneytown Turnpike was extended through Schwenksville. In 1920, this road was macadamized, and in 1947, it was widened, at which time, the old toll house was removed. At the center of this view

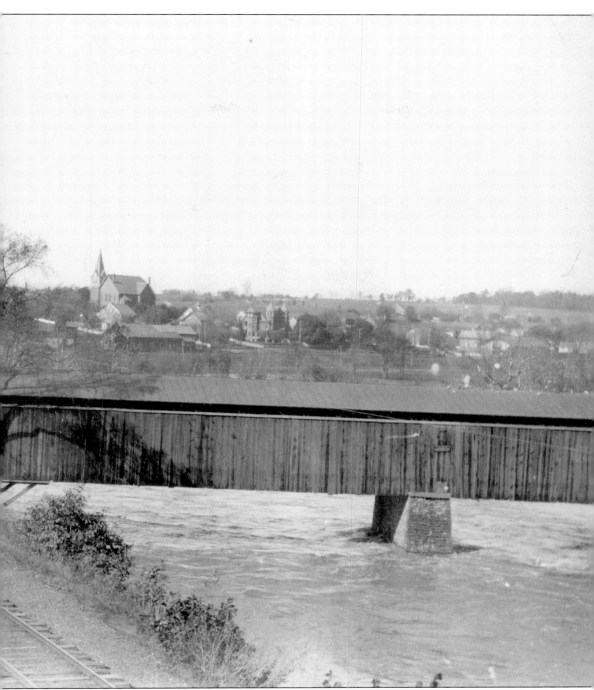

are the tracks of the Perkiomen Railroad Company. A flag man stands just outside of his heated little shack. At right is the covered bridge over the Perkiomen Creek that came to be known as Hunsberger's Bridge. It was built in the 1830s and was burned in a suspected case of arson in 1923. Along the skyline are many of Schwenksville's significant buildings, some of which will appear later in this chapter.

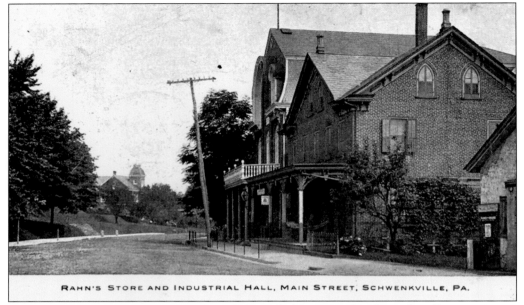

RAHN'S STORE AND INDUSTRIAL HALL, MAIN STREET, SCHWENKVILLE, PA.

Postmarked July 25, 1908, this card is titled "Rahn's Store and Industrial Hall, Main Street, Schwenkville, Pa." This scene greeted travelers as they entered Schwenksville from the south almost 100 years ago. Both buildings have been the home of various businesses. Built in 1874, the Industrial Hall was used by the Bromer family to operate a clothing manufacturing business, which employed about 600 people locally.

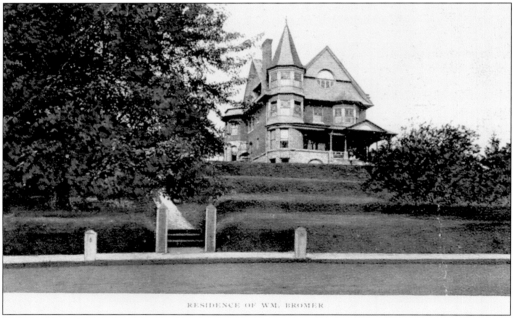

RESIDENCE OF WM. BROMER

Before and after the turn of the 20th century, the Bromer family ran several businesses in Schwenksville. In 1889, William Bromer acquired the clothing manufacturing business from his father. Until his retirement in 1907, William ran the business, which produced about 8,000 garments per week. This Main Street view of his beautiful Victorian residence dates to July 12, 1907.

70

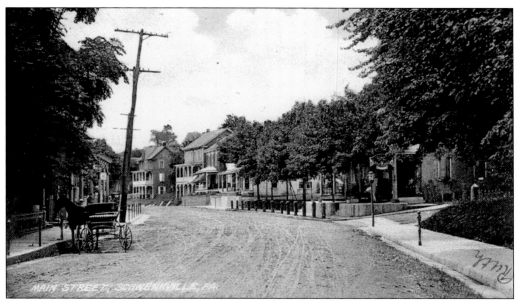

This *c.* 1908 view of Main Street looks south, focusing on the buildings on the west side of the street. The first building on the right, with the heavy hitching posts out front, is the Perkiomen Hotel, the smaller of two hotels in Schwenksville at that time. It advertised "first class accommodations for travelers and drovers" at rates of $1.50 per day. This building was later demolished to make room for an auto service garage.

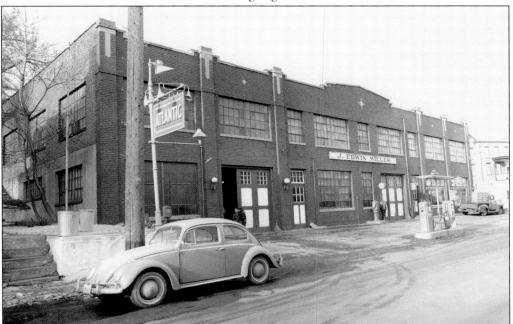

One of the earliest auto repair businesses in Schwenksville was owned in part by Jacob Bromer. He built a garage on the site of the former Perkiomen Hotel and operated there until his death in 1936. At that time, the garage business was purchased by J. Edwin Miller. The full-service garage, seen here in the 1960s, was successfully operated by Miller for 28 years. (Courtesy of Roy Miller.)

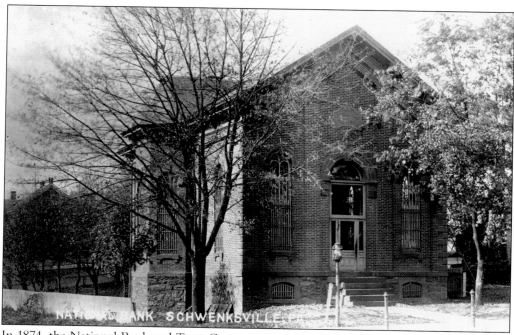

In 1874, the National Bank and Trust Company was organized in Schwenksville. For a while, the bank operated out of the private home of the Bardman family. In 1877, the above new building was completed, and banking continued there until 1927. The present structure, located on the corner of Main and Centennial Streets, was constructed next to the original building. (Courtesy of Roy Miller.)

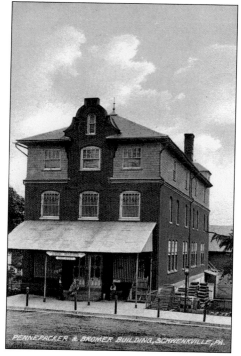

In 1907, Jonas Pennepacker and Jacob Bromer bought the general store and post office on Main Street in Schwenksville. The large store carried a complete line of groceries, clothing, furniture, hardware, utensils, and yard goods. Well-stocked stores like this allowed communities such as Schwenksville to be more self-contained before the coming of the automobile. By the time this card was postmarked, on September 8, 1920, the automobile had already replaced many horse buggies. As a result, Pennepacker and Bromer lost its strategic market edge.

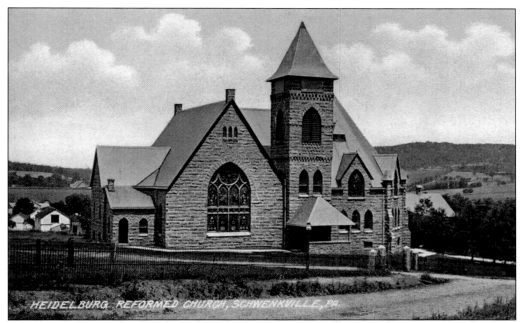

There are several beautiful churches in Schwenksville. One of the most impressive is the Heidelburg Reformed Church. Established as a Union church in 1756, it was chartered in 1835. The building shown above was erected in 1890 and was restored after a fire in 1970. The stones to build the church came from a local quarry and were hoisted into position by horse power.

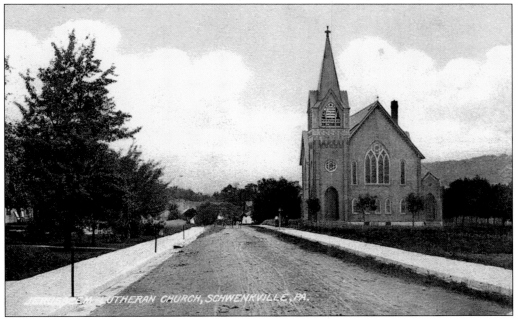

Prior to 1887, the Lutheran and Reformed congregations shared a two-story building located on grounds just outside of Schwenksville. When the congregations outgrew the building, the Lutherans withdrew and, in 1889, occupied the New Jerusalem Lutheran Church. Today, the beautiful Jerusalem Lutheran Church building still looks very similar to this *c.* 1908 postcard view.

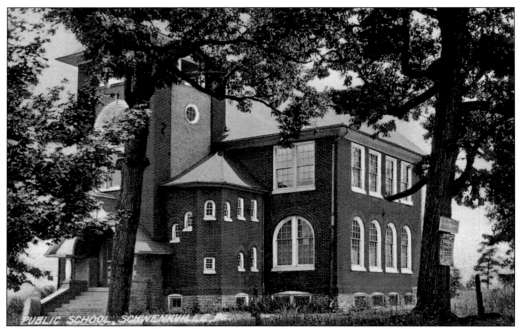

In 1894, the Schwenksville School was built on the Perkiomen Avenue hill. In 1934, it was named the Benjamin T. Miller School in honor of the only person known to have been born on school grounds. Benjamin T. Miller later taught there. The two-story brick building was used as a school until 1969. Later attempts to save the structure failed, and it was torn down in 1980.

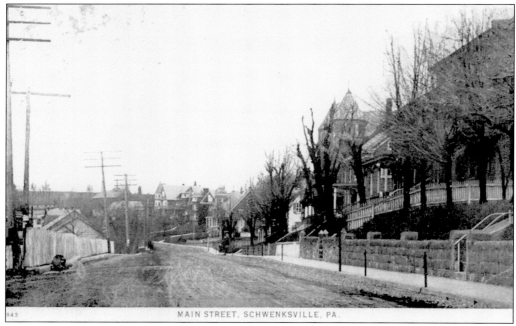

This postcard view, postmarked July 17, 1927, looks south on Main Street from near the railroad station. A present-day photograph of this same area would show that many of the buildings on the west side of Main Street have changed little on the exterior. Of course, Main Street is now paved.

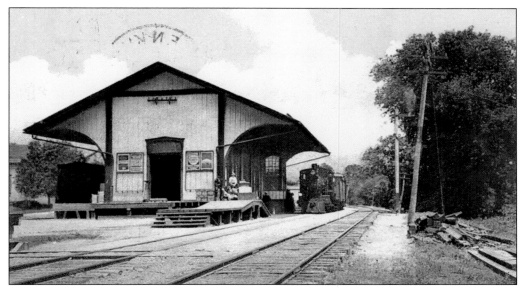

The Perkiomen Railroad Company reached Schwenksville on July 12, 1869. A combined passenger and freight depot was built there, complete with 17-foot-high ceilings and a ticket and telegraph office. This old frame building burned to the ground on March 8, 1942. The station was rebuilt of brick and reopened on April 19, 1943. The brick building still stands on Main Street and has been occupied recently by food service businesses.

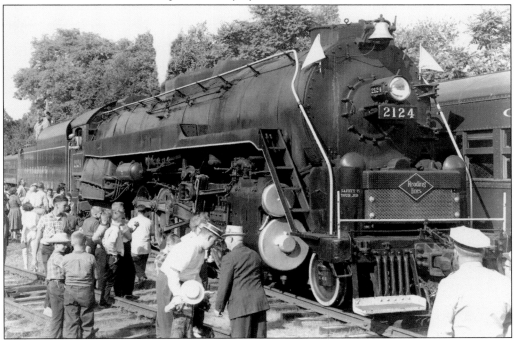

The Iron Horse Ramble was a day of nostalgia that was relived in this September 1960 scene. The Reading Railroad Company sponsored several excursions to various stops years after passenger service had ceased on the line. The highlight was a two-hour stop in Schwenksville, where passengers could disembark for a Pennsylvania Dutch supper. (Courtesy of Roy Miller.)

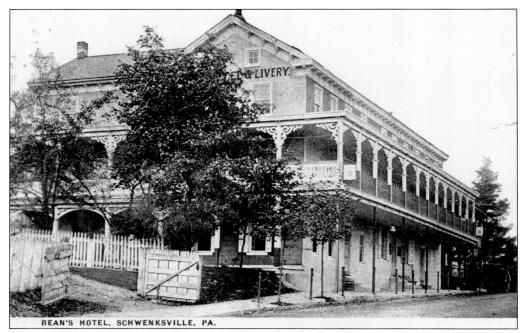

BEAN'S HOTEL, SCHWENKSVILLE, PA.

When the old Farmers Hotel came into the ownership of Charles W. Bean, it was known as Bean's Hotel. It provided the same lodging and livery services as had been enjoyed by travelers for decades. The hotel was also the scene of many dinners and meetings by local business and governmental organizations. During the last 50 years, the building has had several owners, but it is not currently operating as a public hotel.

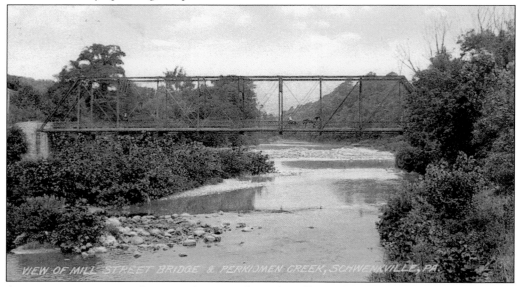

A century ago, anyone who wanted to cross from the village of Schwenksville to the south side of Spring Mountain might have used the Mill Street Bridge. This card, postmarked July 6, 1909, shows a "View of Mill Street Bridge & Perkiomen Creek, Schwenkville, Pa." Today, the span is long gone, but a pedestrian bridge has been erected on the old abutments for use by Perkiomen Trail hikers.

76

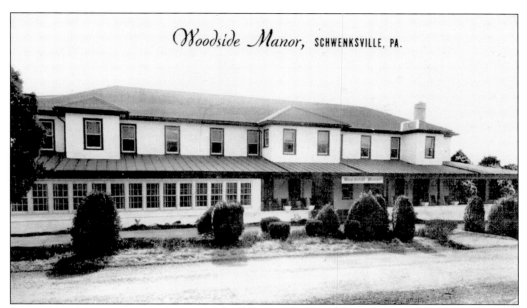

Woodside Manor, a stuccoed masonry building with 41 rooms and 3 tennis courts, was built by Morris Carl in 1925. It operated for many years as a homey countryside resort hotel on the south side of Spring Mountain. In the 1970s, the property was turned into a nursing home, and later became a restaurant called the Woodside Inn.

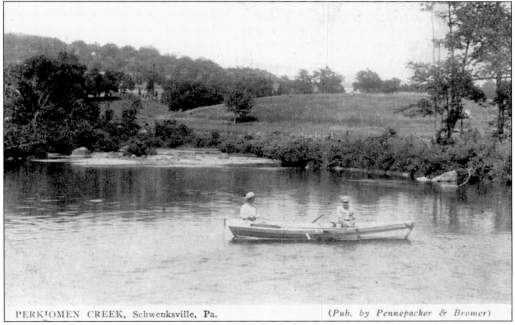

This postcard is one of many published and sold to transient vacationers to promote swimming, boating, and fishing activities on the Perkiomen Creek at Schwenksville. Note that this card shows "Schwenksville" in the title ("s" included); and yet, the postmark from August 19, 1918, still spells the name as "Schwenkville" ("s" excluded). The postal designation was officially changed to Schwenksville in 1951.

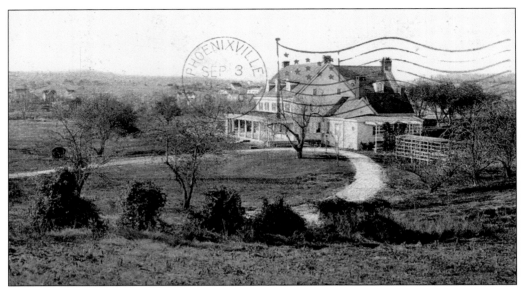

During the Revolutionary War period, George Washington used Pennypacker Mills as headquarters before and after the battle of Germantown. Over many years, the property located along the Perkiomen Creek near Schwenksville was under the ownership of various members of the Pennypacker family. The most notable was Samuel W., who bought it in 1900. He became governor of Pennsylvania on November 2, 1902. The property is now a beautiful historic site operated by Montgomery County.

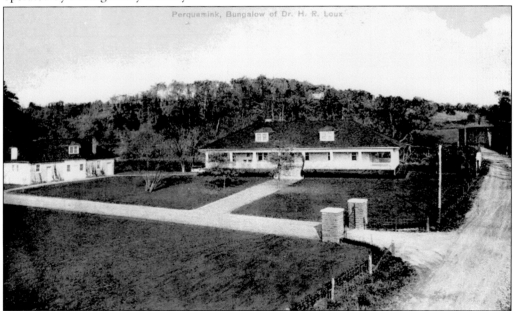

This 1913 card is entitled "Perquamink, Bungalow of Dr. H. R. Loux." The word "Perquamink" was one of several early spellings of what we now accept as Perkiomen. Prior to the ownership by the Loux family, the property had been the site of a three-story frame mill known as Flood Crest. In 1976, the land, located on Plank Road just south of Schwenksville, became part of the Montgomery County park system. It is now referred to as the Old Mill House.

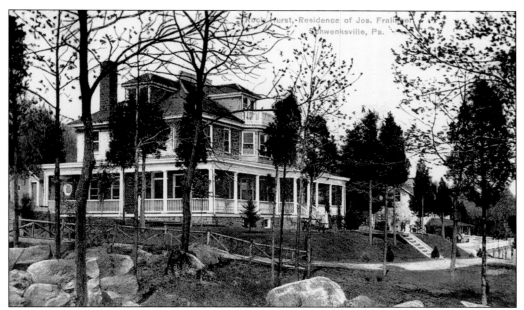

Folks from New Jersey came to the Perkiomen Valley to vacation and rest. One such person was Joseph H. Fralinger. Rockhurst, his showplace on the south side of Spring Mountain, was completed in 1905. The villa was built of local black granite and contained 16 rooms. It was visited regularly by Fralinger and his family until the death of "the Saltwater Taffy King" in 1927.

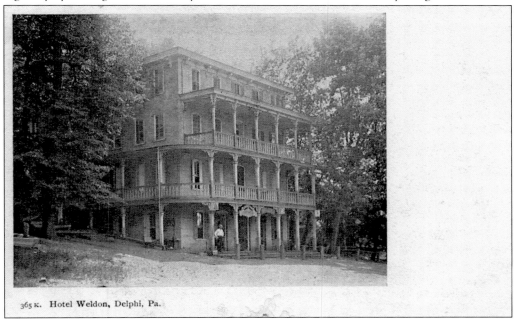

365 K. Hotel Weldon, Delphi, Pa.

The Weldon Hotel was established in 1879 in Delphi, located on the north side of Schwenksville and served by the Zieglersville station of the Perkiomen Railroad. The four-story stone structure was well situated about midway between Allentown and Philadelphia. In the early 1900s, the hotel was one of the most modern of its day. It did a brisk business for decades. Today, a restaurant and bar operate at the site.

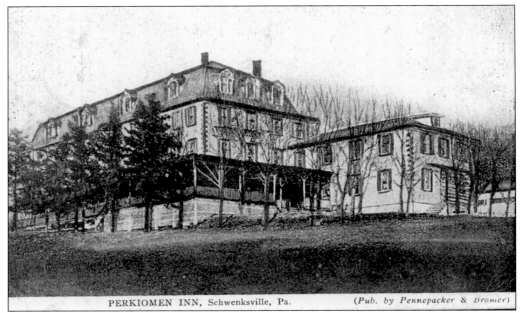

PERKIOMEN INN, Schwenksville, Pa.　　　(*Pub. by Pennepacker & Bromer*)

The Perkiomen Inn, a large, four-story building with fine porches, was situated on the western slope of Spring Mountain. Captured in this 1919 view, the inn commanded an excellent view of the Perkiomen Valley and, with its 56 rooms, accommodated about 100 guests. The surrounding grounds included a golf course and many other lawn facilities. The inn burned to the ground in 1951.

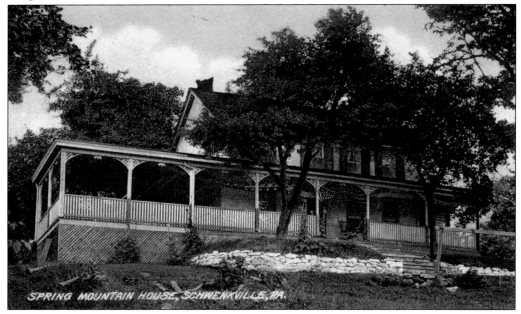

SPRING MOUNTAIN HOUSE, SCHWENKVILLE, PA.

This card, postmarked July 25, 1910, is a hand-colored view of "Spring Mountain House, Schwenkville, Pa." This establishment was one of the earliest to cater to guests seeking to improve their health through rest and country air. The resort, which claimed the ability to cater to as many as 50 guests, was in the hands of the Hobbs family from 1883 until it burned in 1919.

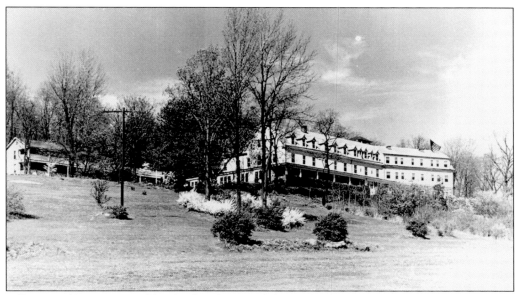

Lillian (Hobbs) Crom and her husband, Samuel, built the newer Spring Mountain House on the site of their old resort. In 1923, the Beltz family purchased the resort and added more rooms and acreage. The literature for the resort dubbed it "The Beauty Spot." The hotel prospered until the late 1940s. It operated briefly as a retirement home, but was finally razed after the 1970s.

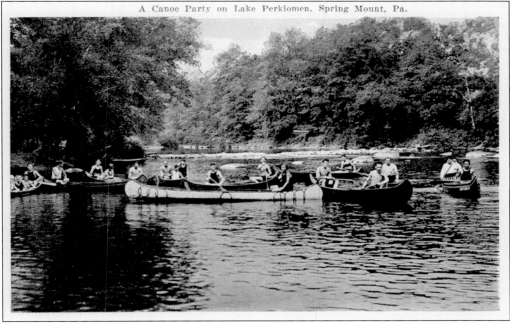

This scene of a canoe party was captured on "Lake Perkiomen" at Spring Mountain in the 1920s. The deep, slow-moving water above the dam in the Perkiomen Creek made boat rentals a good business for the locals. A canoe ride on a moonlit night was very romantic and a perfect way for visitors to get away from the crowds.

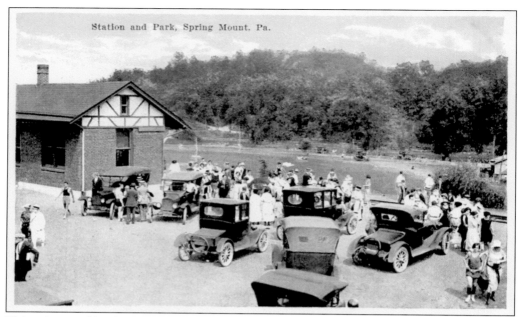

Station and Park, Spring Mount. Pa.

This substantial brick railroad station at Spring Mount replaced an earlier depot that had been a frame structure. This stop on the Perkiomen Railroad was very popular, as seen here in the 1920s. Visitors came by rail and now increasingly by automobile, due to improved roads. The station was in close proximity to a park on the Perkiomen Creek, where there were pavilions, rides, games, water sports, and refreshments.

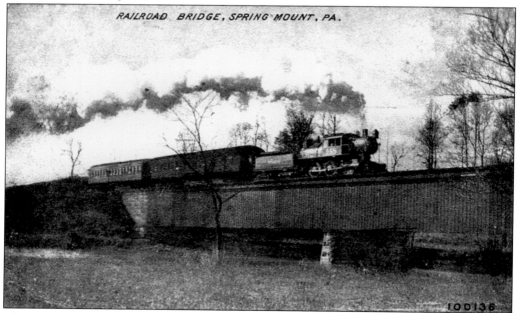

RAILROAD BRIDGE, SPRING MOUNT, PA.

This early-1900s postcard view is titled "Railroad Bridge, Spring Mount, Pa." This bridge carried railroad traffic across the Perkiomen Creek between Lower Frederick and Upper Salford Townships. The locomotive in this scene was an early type that would not be seen much after this image was recorded.

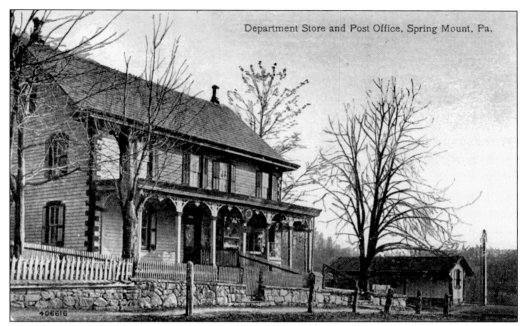

Sent to Philadelphia on July 9, 1911, this postcard reads, "This is the Country Store and Station together called the Village. Evelyn." The sender forgot to mention that the store was also the post office. In 1911, about two dozen homes stood in the immediate vicinity of the general store. Many of the properties were occupied by the Klein family, who had their name attached to the first post office in 1873.

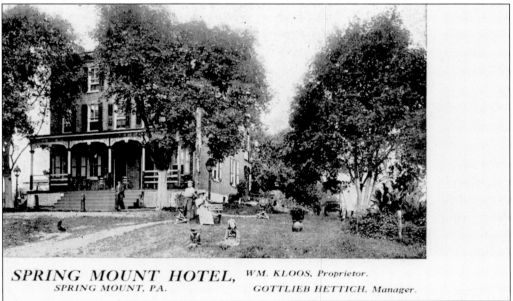

**SPRING MOUNT HOTEL,** WM. KLOOS, Proprietor.
SPRING MOUNT, PA.   GOTTLIEB HETTICH, Manager.

The Spring Mount Hotel, along with the general store, were the two properties closest to the railroad station. Although the hotel was not as large as other Perkiomen Valley accommodations, it possessed all of the country comforts. In this c. 1905 view, the hotel's tree-shaded porch is seen, complete with rockers, swings, and benches, as well as exterior post lighting to guide travelers arriving after dark.

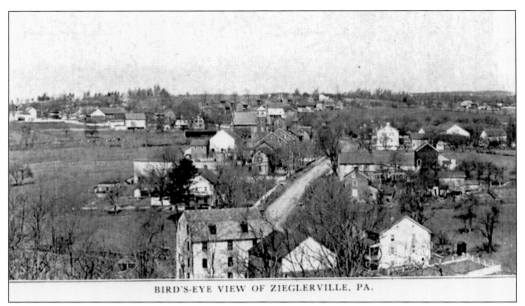

BIRD'S-EYE VIEW OF ZIEGLERVILLE, PA.

Sent to Boyertown on March 9, 1907, this "Bird's-eye View of Zieglerville, Pa." gives only a slight hint of this village's earlier importance as a stagecoach stop along the Big Road to Boyertown. The number of travelers undoubtedly facilitated the establishment of the second newspaper in the Perkiomen Valley; in 1858, the German publication *Wahrherts Freund* (Friend of Truth) was begun.

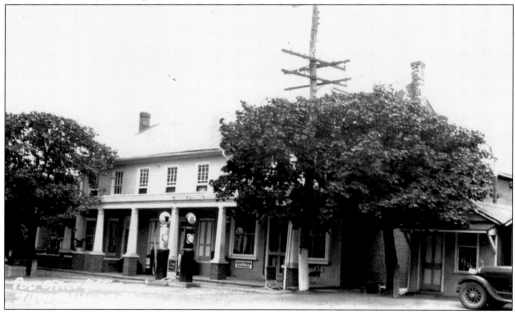

Andrew Ziegler acquired 300 acres of land in 1800. The village later established there eventually took his name. The post office was founded in 1858 as Zieglersville ("s" included). In 1887, the postmark was changed to Zieglerville ("s" excluded). In postcards of the early 20th century, both spellings are commonly found. The above view of the post office and store was sent on October 22, 1936. The store also served as the filling station.

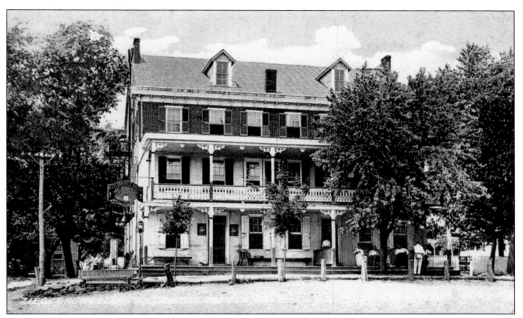

Still in its glory days of the early 1900s is the Zieglersville Hotel, located at the junction of present-day Routes 73 and 29. Early travelers on the way to Pennsburg or Boyertown changed stagecoaches at this hotel. The historic building caught fire in 1981 and subsequently had its third floor removed. Sometime later, the building was razed completely.

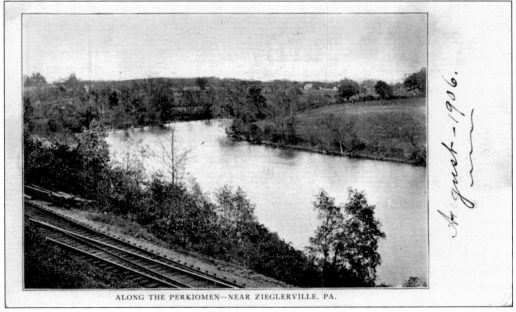

ALONG THE PERKIOMEN—NEAR ZIEGLERVILLE, PA.

This 1906 postcard is titled "Along the Perkiomen—Near Zieglerville, Pa." The key word here is "near," because Zieglerville was not, and is still not, located right on the Perkiomen Creek. In addition, most of the rail stations on the Perkiomen line were named after the towns or villages through which they passed. The Zieglersville station was the exception, since it was actually situated in Delphi.

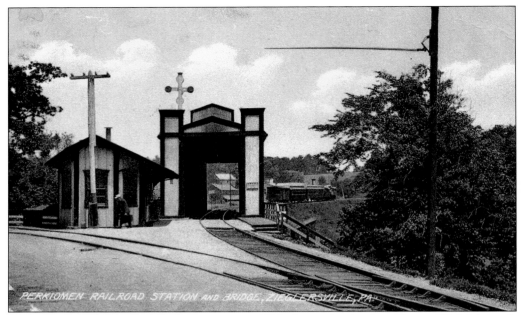

When the Perkiomen Railroad Company established a station in the village of Delphi, locals wanted to call the station Weldon after the nearby hotel. Since there was already a depot by that name elsewhere, the railroad company decided to name it Zieglersville after the post office that had been established under that name. Here, the Zieglersville station and bridge over Swamp Creek appear in 1909.

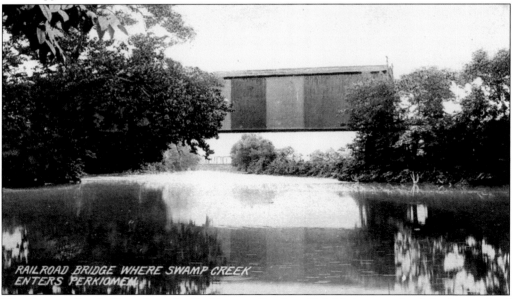

The Swamp Creek flows into the Perkiomen Creek at Delphi, just north of the borough of Schwenksville. Near this juncture, the railroad crossed the Swamp Creek by way of the covered bridge seen in this *c.* 1908 postcard view. The Zieglersville station was located a short distance from the west-end opening of the bridge. This covered bridge was removed in February 1910, and the station was removed in February 1954.

# Six

# SALFORD, PERKIOMENVILLE, GREEN LANE, AND SUMNEYTOWN

The lower portion of the Green Lane Reservoir is located between Upper Frederick and Marlborough Townships. The borough of Green Lane is situated on the east side of the Perkiomen Creek, just below the reservoir dam. The west side of the Perkiomen Creek is the site of the Upper Perkiomen Valley Park. The Unami Creek flows into the Perkiomen Creek at a point below the village of Perkiomenville. Further south, the Perkiomen Creek is the dividing line between Lower Frederick and Upper Salford Townships. The creek passes to the west of places such as Kratz, Hendricks, and Salford.

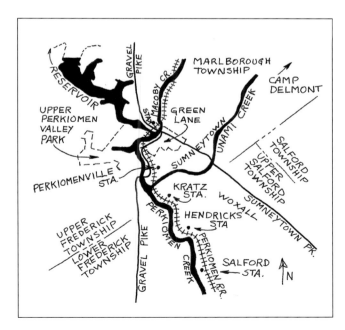

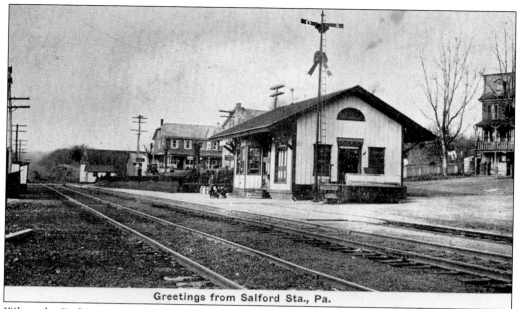

Greetings from Salford Sta., Pa.

When the Perkiomen Railroad came through Rudy in the early 1870s, the village was sparsely populated. The railroad company called the stop Ziegler's Mill. Later, the railroad changed the name of the station to Salford, while the locals continued to call the village Rudy for a time. When the above view was recorded, around 1910, Salford had grown to include a hotel (at right), a store (behind the station), and various other residences. (Courtesy of Roy Miller.)

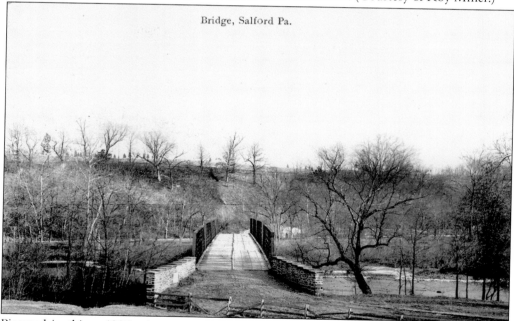

Bridge, Salford Pa.

Pictured in this *c.* 1907 winter scene is the bridge that carried traffic across the Perkiomen Creek on Salford Station Road. It stood just a short distance from the Salford railroad station. Some time in the 1930s, the bridge was razed because a new one had been constructed nearby on the downstream side. (Courtesy of Roy Miller.)

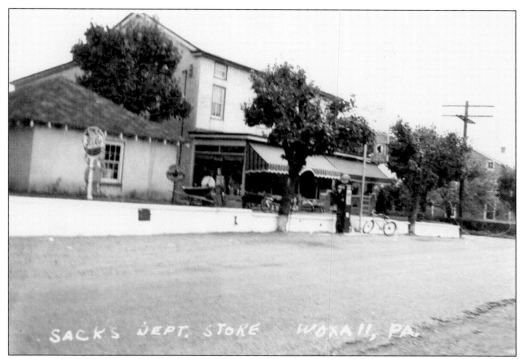

The village of Woxall lies along Old Skippack Road, a short distance from the east side of the Perkiomen Creek. Prior to 1888, the village was known as Mechanicsville, and much earlier as Crowtown. The above card, postmarked October 14, 1949, is a classic mid-century view of "Sacks Dept. Store, Woxall, Pa." Judging from the many signs and merchandise displayed out front, this store and gas station sold a little bit of everything.

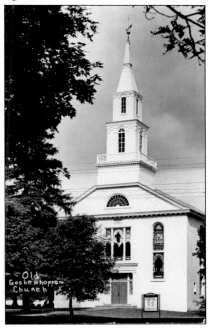

The Old Goshenhoppen Church is situated between Salford and Woxall. In 1732, a group of Lutheran and Reformed Christians joined forces to buy land and build the first church. The building in this view was constructed in 1858, and was renovated and enlarged in 1915. The graveyard surrounding the church holds the monuments of many of the area's early settlers.

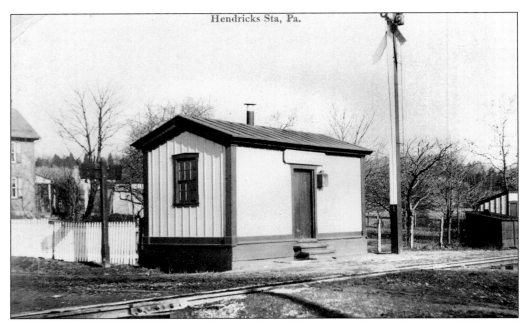

The Perkiomen Railroad stations of Hendricks and Kratz were located between Salford and Green Lane. Both stations were of smaller size and rather modest construction. Their main purpose was to serve a busy mill at Hendricks and a thriving ice company at Kratz. In the above postcard view is the station at Hendricks, as it appeared around 1907. (Courtesy of Roy Miller.)

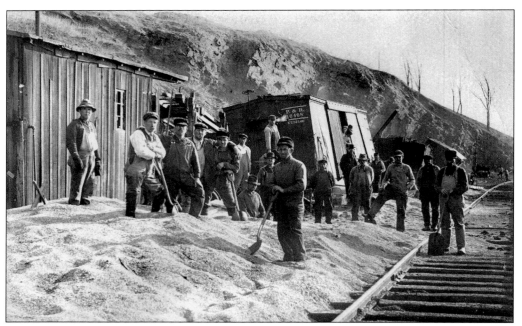

Train derailments or wrecks along the Perkiomen Railroad line were not common; nor were they rare. Around 1907, this derailment took place in Upper Salford Township, near the rock quarry that operated between the Hendricks and Kratz stations. This cleanup crew has a lot of grain to shovel. (Courtesy of Roy Miller.)

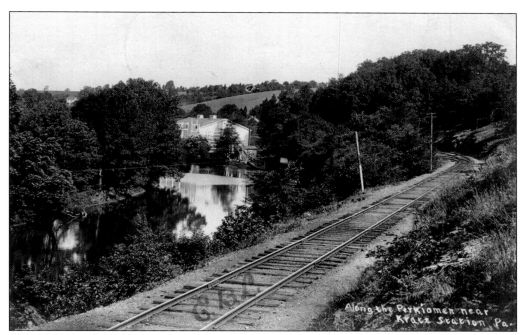

Titled "Along the Perkiomen near Kratz Station, Pa." and postmarked January 7, 1913, this card gives a good look at the creek and close proximity of the rail tracks in that area. In the distance is the icehouse that kept the Kratz station busy for a number of years. (Courtesy of Roy Miller.)

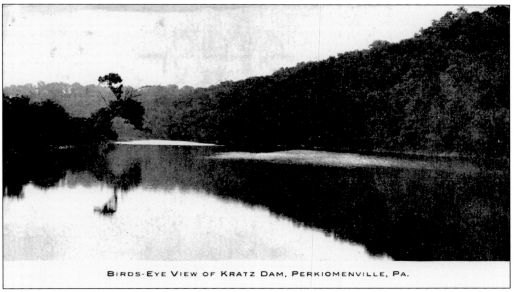

BIRDS-EYE VIEW OF KRATZ DAM, PERKIOMENVILLE, PA.

This is a "Birds–Eye View of Kratz Dam, Perkiomenville, Pa." The dam was named for the Kratz family, who had run a gristmill near Perkiomenville. The dam was located a short distance downstream of the point where the Unami Creek flows into the Perkiomen. The Unami had previously been known as Swamp Creek, but was changed to avoid confusion with the other stream by the same name further south.

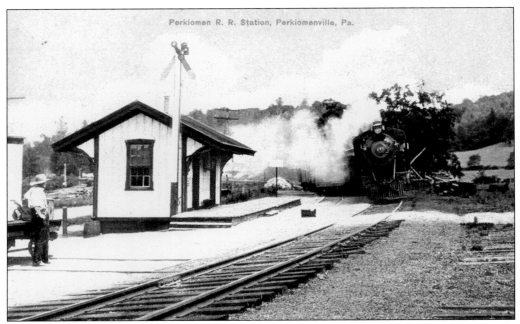

The Perkiomen Railroad Company's extension from Collegeville reached Perkiomenville by 1872. The above *c.* 1907 view shows the wooden station house, designed in an earlier style typical of country stations with limited activity. Also, a steam locomotive heads north, preparing to stop and take on freight being guarded by the gentleman with the straw hat. Below, a postcard sent on August 20, 1952, shows the replacement brick station constructed at Perkiomenville in 1909. This depot is similar to other brick stations that were constructed along the line to serve stops with increased activity.

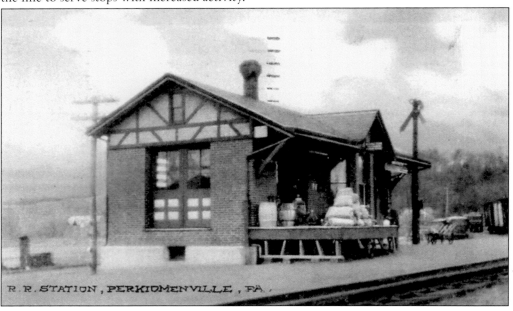

R. R. STATION, PERKIOMENVILLE, PA.

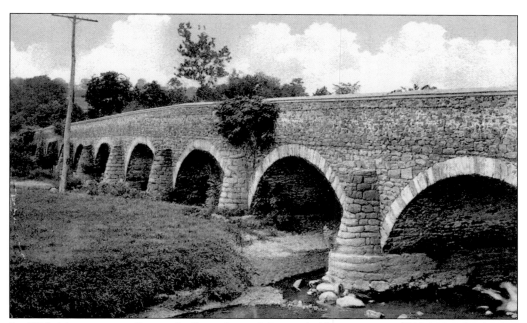

In 1839, Montgomery County built a substantial stone bridge at a cost of $11,000. This bridge was constructed to span the Perkiomen Creek at Perkiomenville. The bridge, seen here on a card postmarked August 18, 1910, still stands, although it was not used for traffic after 1967.

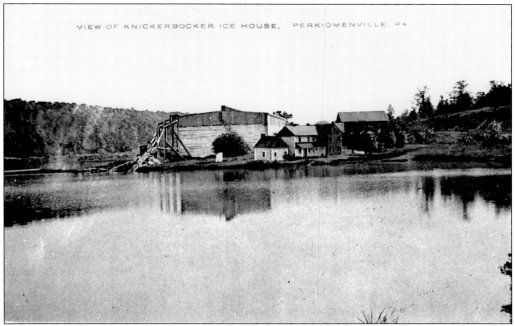

In this 1912 postcard, entitled "View of Knickerbocker Ice House, Perkiomenville, Pa.," the large size of the main storage building is evident. The ramp, which would have been powered by horses at one time, lifts ice blocks aloft. Much of the ice was sent to the cities, but local creameries, butchers, stores, morticians, and farmers were also regular customers.

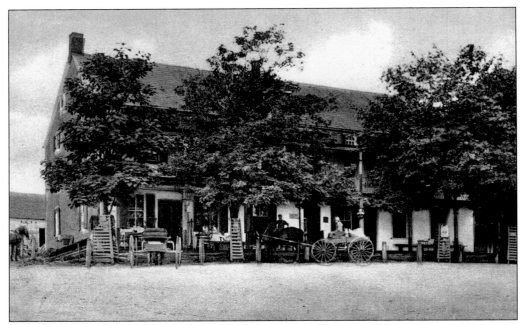

The Perkiomenville Hotel, shown around 1907, was a popular eating and meeting place because of the livestock auction held in a nearby building. There, local farmers bought and sold their own livestock, as well as cattle that had been shipped into the Perkiomenville railroad station. In 1938, the sale was moved behind the railroad station in Marlborough Township. (Courtesy of Roy Miller.)

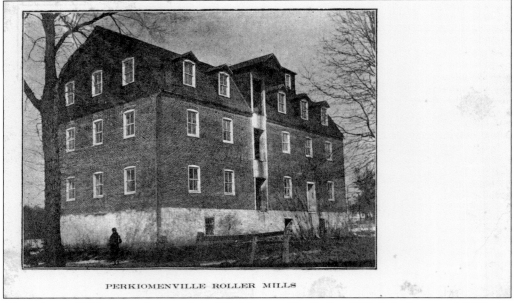

PERKIOMENVILLE ROLLER MILLS

Above is a *c.* 1907 postcard view of the "Perkiomenville Roller Mills." Built around 1850, the mill was located in Marlborough Township along Gravel Pike. The large brick building was designed and constructed by the Nyce family, who operated the gristmill for many years. The Nyces were early industrialists in Montgomery County. (Courtesy of Roy Miller.)

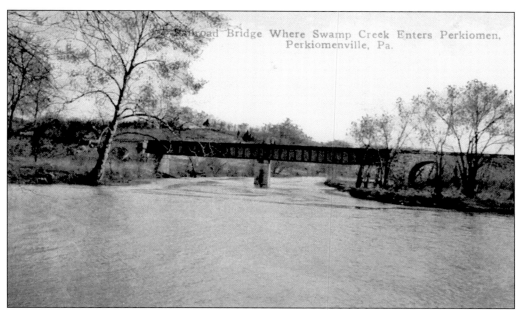

Postmarked August 1, 1917, this view reveals the "Railroad Bridge Where Swamp Creek Enters Perkiomen, Perkiomenville, Pa." In 1917, the United States Geographic Board concluded that there were too many "Swamp Creeks." Therefore, this particular creek was given the Native American name of Unami. However, Swamp Creek Road, which follows the creek, retains its original name.

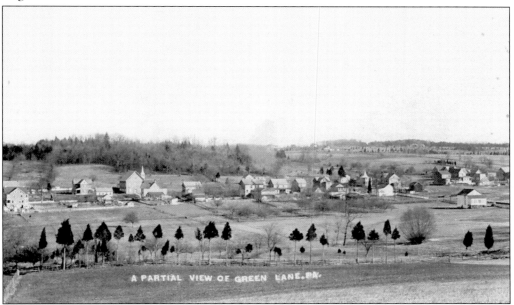

This real-photo postcard shows "A Partial View of Green Lane, Pa." The village of Green Lane was named after the old Green Lane Forge, which had itself been named for the green foliage of the evergreens and pines that covered the surrounding rocky hills. Even though this *c.* 1908 scene was captured in wintertime, a careful inspection reveals the many fields and orchards under cultivation.

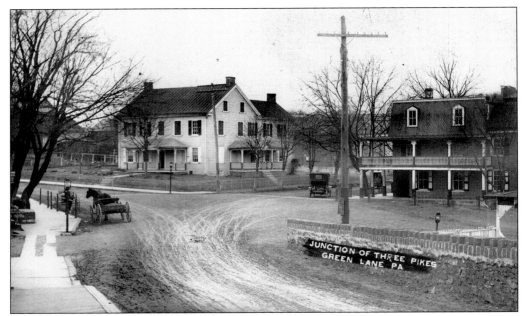

Green Lane lies at the junction of three old turnpikes that were completed between 1848 and 1851. From this intersection, two of the turnpikes became our familiar Route 29 North and South. The third, Route 63 East, became the borough's Main Street. In this *c.* 1907 view, the Green Lane Hotel stands at right, while an automobile heads south on Route 29. Main Street is on the left, in front of the horse and wagon. (Courtesy of Roy Miller.)

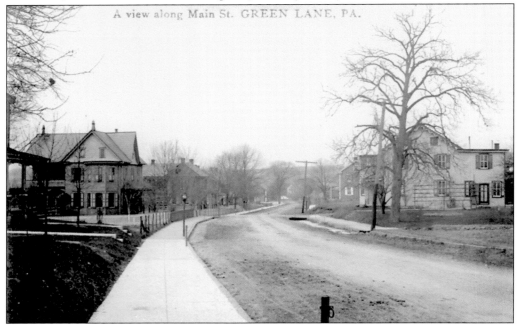

This postcard, entitled "A View Along Main St. Green Lane, Pa." and postmarked September 24, 1909, shows the newly laid concrete sidewalk on Main Street. Seen to the left of center is one of the first streetlights. These oil-fed lamps had been in use since 1890.

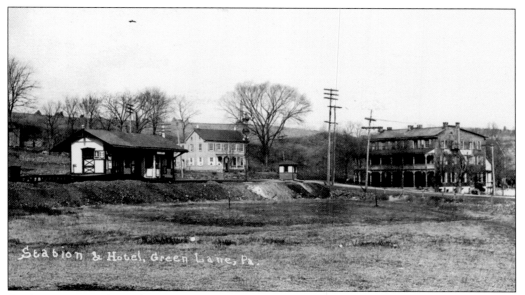

Station & Hotel, Green Lane, Pa.

At Green Lane, the rail station and nearby hotel were important in keeping the ice and stone industries flourishing during the early part of the 1900s. At one time, this station was open 24 hours a day. Old-timers remember that meeting the mail train every day gave townspeople a chance to socialize. Train service to Green Lane ended in 1961, and the station was torn down in 1966.

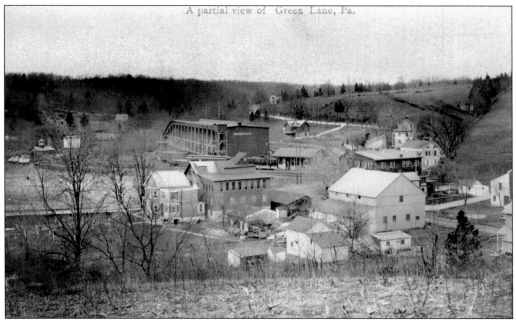

A partial view of Green Lane, Pa.

The large building near the center of this c. 1906 view of Green Lane is the Hancock Ice Company. It was constructed on the same site as the original Green Lane Forge. Centuries ago, the forge had been the earliest industry in the area. The icehouse was 312 feet long and 90 feet wide, and it held 25,000 tons of ice. This building burned to the ground in March 1907 and was rebuilt later that year. (Courtesy of Roy Miller.)

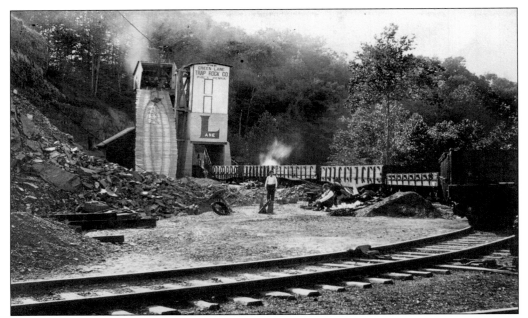

Several successful quarries operated in the Upper Perkiomen region in the early 20th century. Some of the quarries needed teams of heavy draft horses to carry stone to the nearest railroad station. In this *c.* 1910 view, the Green Lane Trap Rock Company is in operation. This company was fortunate enough to have a rail siding for direct loading to railcars. (Courtesy of Roy Miller.)

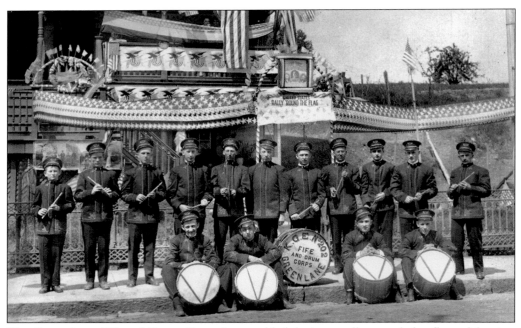

The Green Lane Fife and Drum Corps is assembled during a rally-round-the-flag celebration about 1914. The band was organized in January 1912 under the sponsorship of the Knights of the Golden Eagle Lodge No. 202. The group disbanded in 1926. (Courtesy of Roy Miller.)

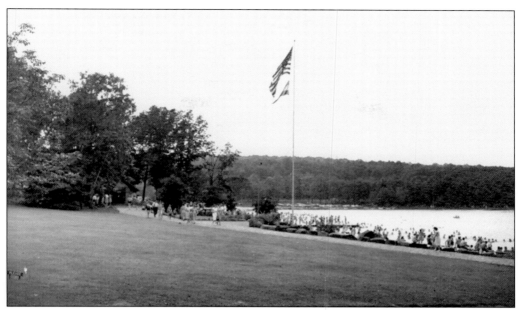

When this postcard view of the "Upper Perkiomen Valley Park, Pa." was taken in the 1940s, the park was still a new phenomenon but was already well patronized. In 1939, the commissioners of Montgomery County had purchased a 425-acre tract of land in Upper Frederick and Marlborough Townships. Subsequent additional purchases have increased acreage to the park, which offers swimming, boating, picnicking, and fishing.

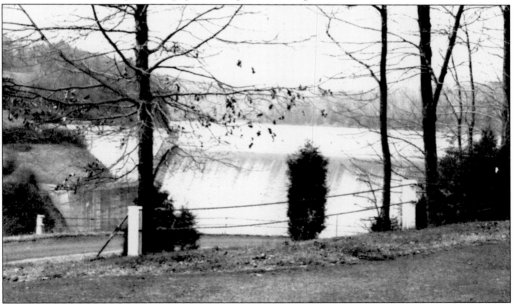

As early as 1865, the Philadelphia Water Department considered the Upper Perkiomen Valley as a source of water supply for the city. After much development, acquisition of land, and legal battles, the construction of the Green Lane Reservoir began in October 1954. This massive project was completed in November 1956. The reservoir has a depth at the dam of 66 feet, a shoreline of 19 miles, and an area of 815 acres.

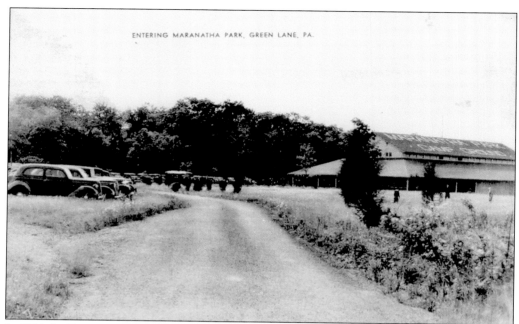

In 1931 the Eastern District Council of the Assemblies of God opened Maranatha Park on Gravel Pike above Green Lane. The district developed the grounds with cottages and, in 1934, built a tabernacle capable of seating 3,000 members. By 1980, the organization had sold the property.

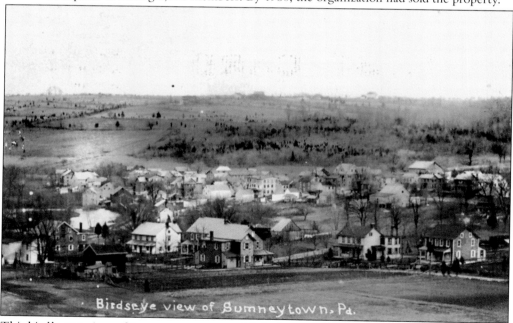

Birdseye view of Sumneytown, Pa.

This bird's-eye view of Sumneytown was published around 1906. Isaac Sumney is commonly thought to be the founder of Sumneytown. He came to America in the first half of the 18th century, and seven of his children were baptized in the Old Goshenhoppen Church. Although not one of the earliest settlers, Sumney was an innkeeper, and therefore, the village was named for him.

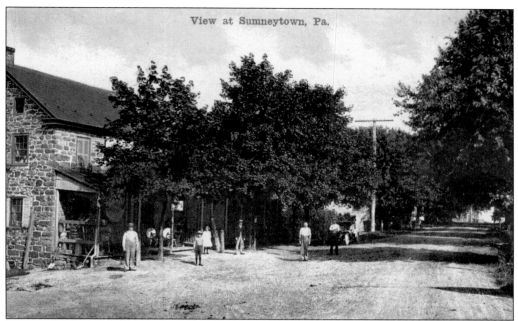

In this "View at Sumneytown, Pa.," the Sumneytown General Store appears at left. When this card was postmarked, on September 23, 1916, the store had been operating continuously since 1790. Obviously, the store had many different owners over the years. In addition, the building had various changes, and was modernized throughout its long tenure. (Courtesy of Roy Miller.)

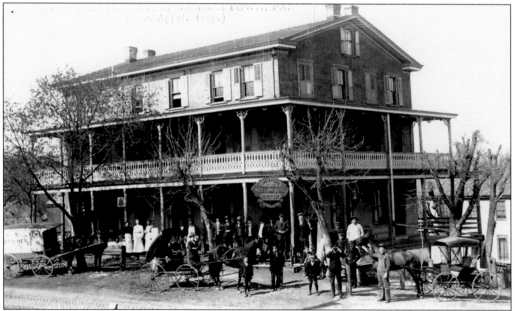

This three-story brick hotel was erected in 1875, after a fire destroyed the Sumneytown Hotel, which had been built on the same site in 1762. On a beautiful spring day around 1907, a large group of folks posed in front of the Red Lion Hotel for this postcard image. The card also indicates that the proprietor at the time was George Appel.

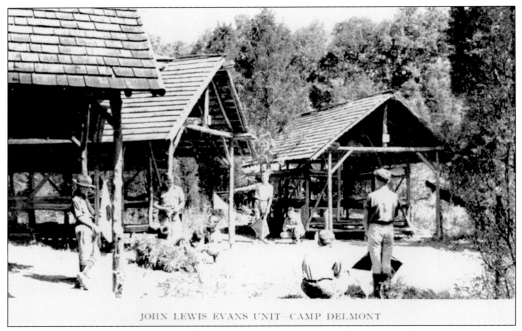

JOHN LEWIS EVANS UNIT—CAMP DELMONT

In 1918, the Valley Forge Council of Boy Scouts purchased 396 acres of land in the area of the Unami Creek. Boy Scouts from Delaware and Montgomery Counties have camped there ever since. In 1930, Camp Hart, located on the northeast side, came into the ownership of the Philadelphia Council. Today, both camps are part of the Musser Scout Reservation, and receive more than 1,000 boys per week during the summer.

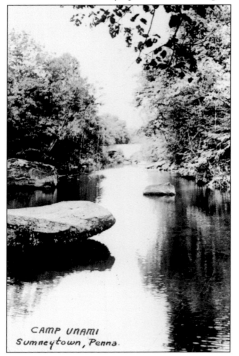

CAMP UNAMI
Sumneytown, Penna.

This peaceful postcard scene of the Unami Creek was postmarked August 10, 1939. The sender was writing home to Flushing, New York. In fact, most campers who came to the Sumneytown area to enjoy the beauties of the Unami Creek came from urban areas or nearby states. As evidenced here, the Unami is full of boulders at most places for a distance of 8 to 10 miles. In some places, the creek disappears under the rocks.

*Seven*

# RED HILL
# AND PENNSBURG

Red Hill and Pennsburg were originally part of Upper Hanover Township. Together with East Greenville, the adjoining boroughs are still completely surrounded by the township. The Macoby Creek runs southward on the east side of the three boroughs. The upper section of the Green Lane Reservoir is in close proximity, just west of Red Hill and Pennsburg. A half century ago, the reservoir construction claimed hundreds of acres of prime farmland in that area.

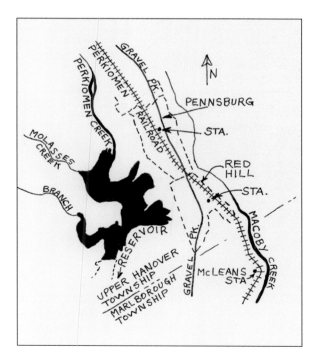

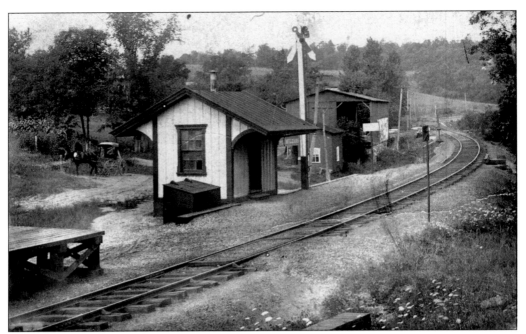

The McLeans station of the Perkiomen Railroad, seen here around 1905, was located between Green Lane and Red Hill. This portion of the township was predominantly farmland and open space. The depot stood near a creamery and coal yard and was considered a "flag station." Trains stopped at these stations only upon a deployed flag signal. (Courtesy of Roy Miller.)

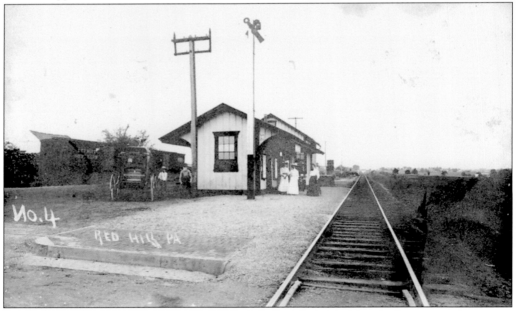

Before the advent of the railroad, residents of the area around Red Hill were accustomed to taking the stagecoach to Philadelphia. The round trip took three full days. After 1874, the folks could go by train in the morning, conduct business, and return early in the same evening. This view shows a group of travelers at the Red Hill station around 1906.

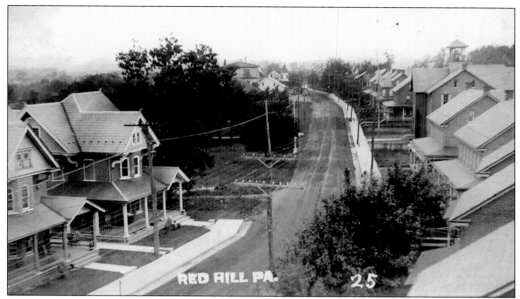

These two views of Red Hill show portions of the borough as they appeared in the early 20th century. As a village in the early 1800s, it was known as Hillegassville. This earlier name honored residents who were members of the Hillegass family. When the first post office was established on the lower end of the village in 1859, it was called Red Hill. The designation was adopted due to its location and the color of a hill along the Green Lane and Goshenhoppen Turnpike. Red Hill became a borough in 1902. In the above view, we see an image of Main Street, with the distinctive spire and conical roof of the Red Hill Hotel in the far distance. In the view below, a pedestrian tries out the newly laid concrete sidewalk as an early automobile makes its way down Railroad Avenue.

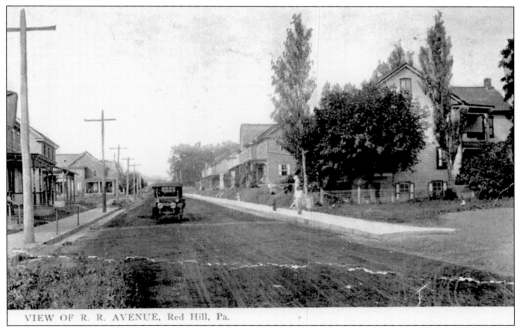

VIEW OF R. R. AVENUE, Red Hill, Pa.

An early site of the Red Hill Post Office is seen in this *c.* 1920 postcard view. Originally established in 1859, the post office had several different locations until 1970. At that time, the borough purchased the old 1924 fire hall and renovated the first floor for post office operations.

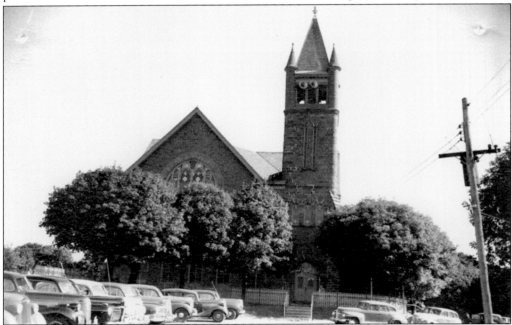

This postcard, sent to Souderton on December 15, 1947, shows "St. Paul's Lutheran Church, Red Hill, Pa." St. Paul's was recognized as the church of the town, since no other was within borough limits. It is one of the oldest congregations in the state, with baptismal entries dating back to 1737. The church building depicted here was erected in 1896.

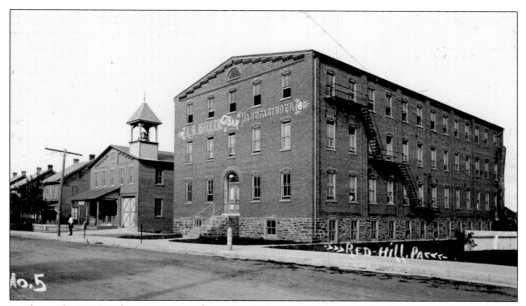

In the early 1900s, the cigar manufacturing industry was among the largest employers in the Upper Perkiomen Valley. In Red Hill, Lucien B. Miller was a leading manufacturer and a public figure in the borough. Miller and other entrepreneurs were instrumental in constructing numerous brick houses for employees. In addition, they erected other buildings, such as the first fire house, pictured above next to the Miller factory on Main Street.

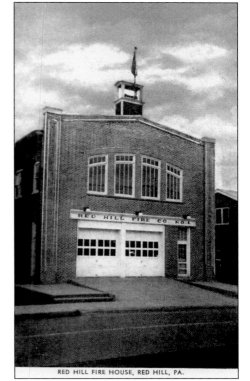

The second fire hall for Red Hill was dedicated on October 25, 1924, on Main Street below Fifth. The building included a basement grill room, a meeting room, and two truck bays on the main floor. The second floor was used for assemblies and sports. Later, the fire company outgrew this building, and a new fire hall was dedicated in 1970 on East Fifth Street.

RED HILL FIRE HOUSE, RED HILL, PA.

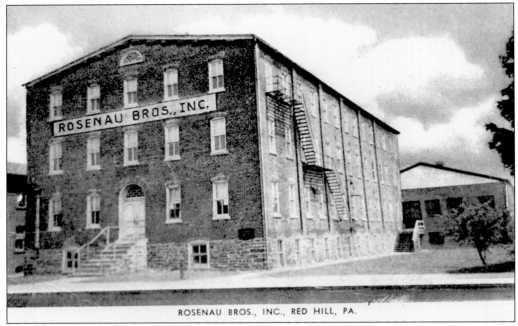

ROSENAU BROS., INC., RED HILL, PA.

The region's handmade cigar industry began to lose strength in the 1920s. Large-scale, machine-based mass production was being employed in other locations. Many local cigar companies began to close. The vacant facilities were then taken over by other industries. One such company is shown in this *c.* 1925 postcard view, entitled "Rosenau Bros., Inc., Red Hill, Pa." In 1924, the Rosenau brothers had begun a children's clothing manufacturing business.

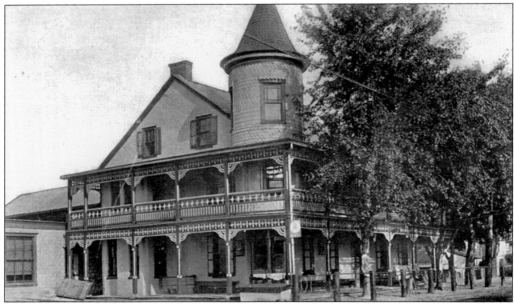

The Hillegass family built quite a few of the early structures in Red Hill. This *c.* 1915 postcard view shows the hotel built by George Hillegass in 1811. Originally, it was known as the Hillegassville Hotel and later as the Red Hill Hotel.

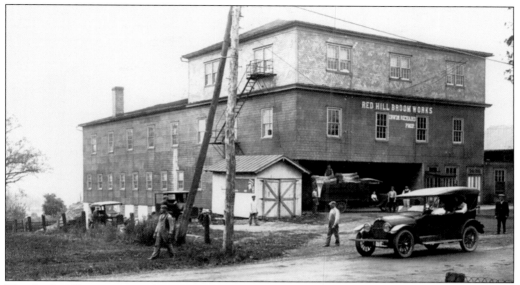

The Red Hill Broom Works was one of the longest-operating enterprises in the area. Irwin Richard founded the company in a building erected in 1906 adjacent to the Red Hill Hotel. The business continued in the Richard family until 1974, when it was sold to the Hamburg Broom Works. Here, a delivery truck is being loaded.

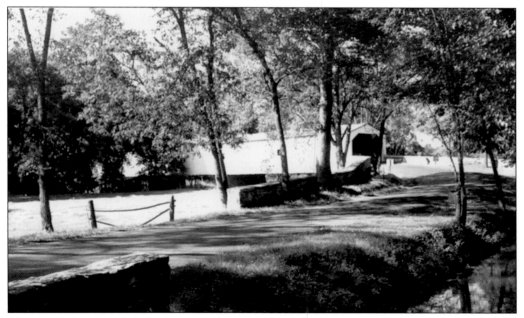

This *c.* 1920 postcard depicts Montgomery County's last covered bridge, which spanned the Perkiomen Creek in Upper Hanover Township. Built in 1835, the bridge consisted of four spans with a total length of 301 feet. In 1950, when plans to construct the dam at Green Lane were announced, the fate of the bridge came into jeopardy. Efforts to save it failed, and it was replaced by a modern bridge in 1958.

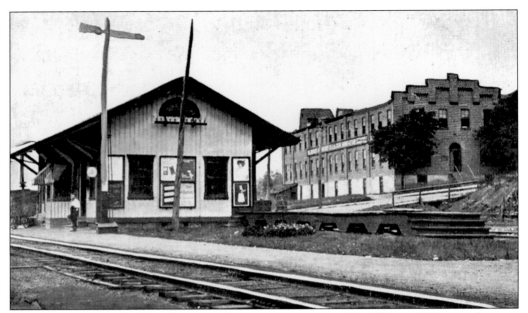

The Perkiomen Railroad reached Pennsburg on October 6, 1873. This *c.* 1920 view, showing a station house constructed about 1914, is labeled "P&R Station" because the railroad was controlled by the Philadelphia and Reading Company. On the right side of the station is the Theobald-Oppenheimer cigar factory. Still standing, the station house is currently used as private residences and an office.

After the Perkiomen Railroad was completed to Pennsburg in 1874, Capt. Henry H. Dotts saw an opportunity. The developer built the American House Hotel on Fourth Street, just across the tracks from the rail station. The hotel had several different proprietors before being acquired by Horace B. Harley in 1900. At a later time, it was renamed the Hotel Harley.

The Pennsburg Hotel, shown here around 1907, was built by George Graber in 1846. The hotel stood at the northeast corner of Main Street (Route 29) and Fourth Avenue (Route 663). After operating continuously for 115 years, the hotel building was razed.

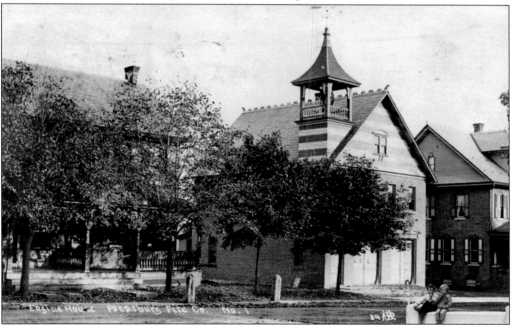

When this card was postmarked on August 19, 1918, the Pennsburg Fire Company owned no motorized equipment. The company had been organized in 1897 in this building, which doubled as a town hall. The fire company began with a hose carriage and ladder wagon, each horse drawn. The first fire chief was local dentist Dr. Charles Q. Hillegass. A new three-bay fire hall replaced the first in 1924.

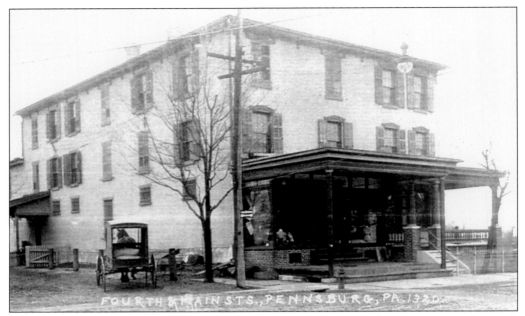

One of the oldest businesses in Pennsburg stood at the corner of Main Street and Fourth Avenue. In 1852, Jacob Hillegass erected a three-story building, where he conducted an active general department store business. At the time of this *c.* 1909 view, the store was operated by the partnership of Gilbert and Hevener. At the end of World War II, the store was modified and expanded.

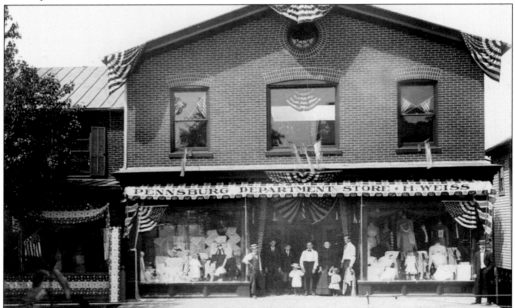

A popular clothing store on Main Street in Pennsburg about 1912 was the H. Weiss Department Store, which carried a full line of family clothing, as well as housewares. Using magnification on the above photo postcard, we learned that a ladies full-length formal dress sold for $5.98. Note how the store is decked out with flags in celebration of a patriotic holiday.

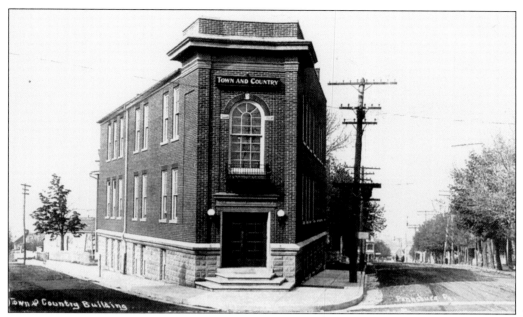

In 1899, Dr. Charles Q. Hillegass, a Pennsburg dentist, and Robert Singer, a clerk in a Pennsburg drugstore, ventured into the publishing field. They established a weekly newspaper called *Town and Country*. The newspaper building is seen in this *c.* 1906 postcard. The newspaper continued in the Hillegass family until 1977, when it was sold to the Equitable Publishing Company of Lansdale.

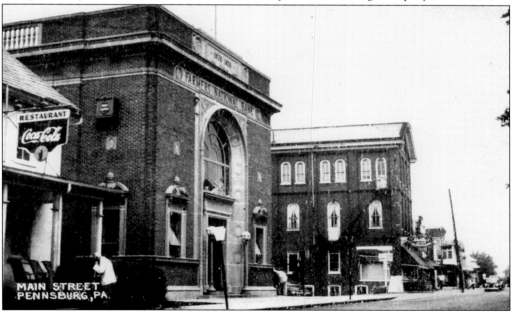

A pair of Pennsburg's notable buildings are shown in this 1940s view of Main Street. On the left is the Farmer's National Bank. On the right is the building erected by the Independent Order of Odd Fellows in 1875. The bank first opened its doors for business on May 6, 1876, in a small room on the main floor of the Odd Fellows Hall. In 1926, the bank moved into its new building on the opposite corner.

113

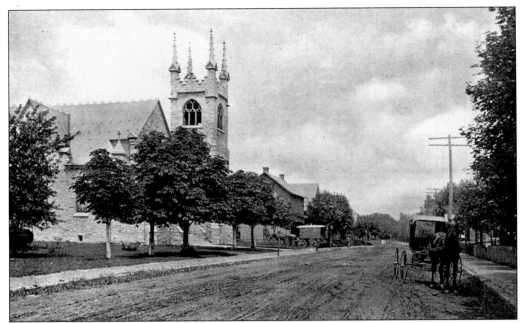

This early view from around 1907 is titled "Along Main Street, Pennsburg, St. Mark's Lutheran Church." St. Mark's Lutheran Church had erected this impressive light-colored stone structure on Main Street at a cost of $16,000. The dedication took place on June 3, 1900. Through the efforts of the Ladies' Aid Society, a tower bell was installed in 1902.

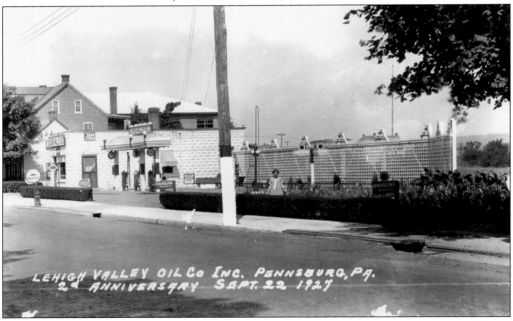

Shown here is a classic c. 1927 automobile service station in Pennsburg. As evidenced here, the Lehigh Valley Oil Company sold its own brand of gasoline, as well as Betholine and a third brand (unreadable). One sign promotes, "Drive on, free crankcase service," and others advertise the AAA Auto Club, Mobil and Havoline oil, and Firestone tires.

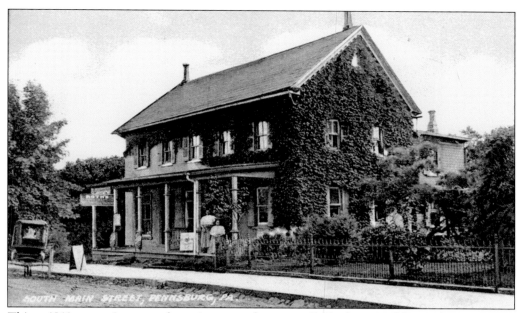

This *c.* 1911 souvenir postcard was just one of many available from Roth's Confectionery and Dining Parlors. Shown above, Roth's was located at 419 Main Street, Pennsburg, for many years. As one of the leading eating establishments in the Perkiomen Valley, Roth's served meals cooked to order, at all hours of the day. This historic building was razed in 1978 to provide space for a drive-through window for the adjoining bank.

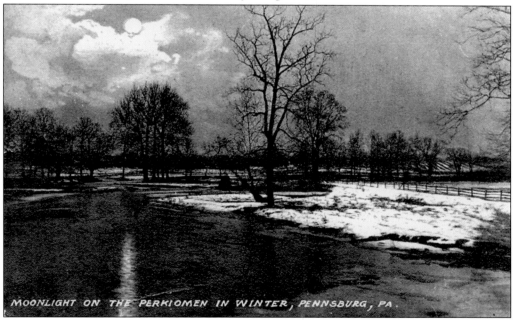

The Perkiomen Creek flows into the Green Lane Reservoir on the west side of Pennsburg. Prior to the construction of the dam, the creek flowed on by both Pennsburg and Red Hill and exited Hanover Township into Frederick Township. In this unusual moonlight-winter view from 1910, the beautiful Perkiomen Creek is surrounded by farmland that is now likely under water.

115

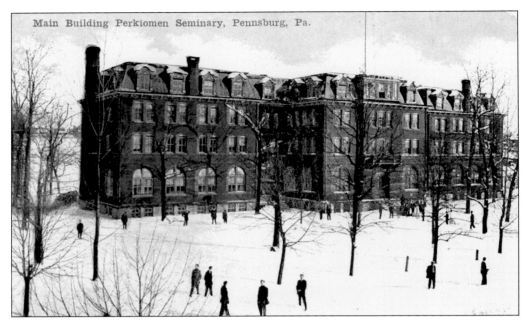

Main Building Perkiomen Seminary, Pennsburg, Pa.

The Perkiomen Seminary got off to a rocky start in 1875, but by the early years of the 20th century, it was well established as a community cultural center for Pennsburg and surrounding areas. Pictured is the school's main building as it appeared about 1908. At that time, the school was coeducational, but in 1919 it became an all-boys' school. In 1969, the school returned to coeducational status.

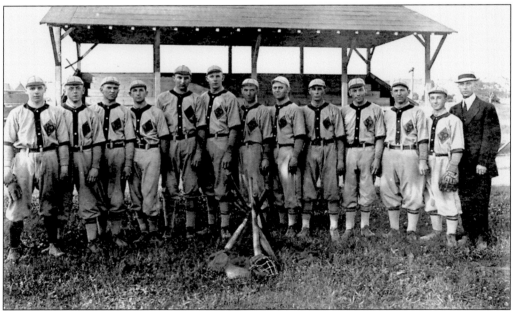

Baseball was one of the most popular sports in Pennsburg, drawing many different teams of amateurs from 1890 through the 1950s. The 1913 Perkiomen Seminary team is pictured above. The previous year, this same team had a record of 14 wins and only 1 loss. It had defeated teams such as Drexel, Moravian, Ursinus, Swarthmore, and others. The sole loss was to St. Joseph's College.

# Eight

# EAST GREENVILLE
# AND PALM

East Greenville is on the north side and contiguous with the boroughs of Pennsburg and Red Hill. For the southbound traveler, Gravel Pike becomes Main Street at East Greenville and continues accordingly through the remaining two boroughs. The village of Palm sits very near to the northwest corner of Montgomery County. The bordering counties of Berks, Lehigh, and Bucks provide the various small streams and creeks that feed the upper reaches of the Perkiomen Creek.

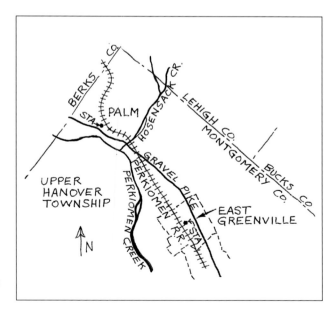

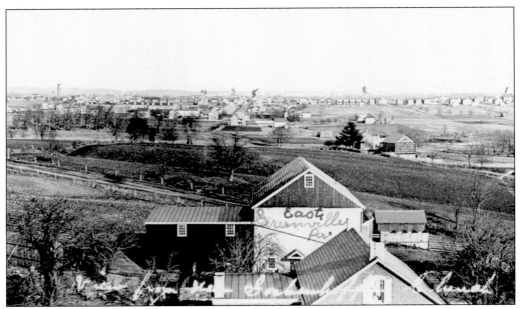

This view of East Greenville was captured on New Year's Day 1905 and was taken from the steeple of the New Goshenhoppen Church. The name "East Greenville" was suggested in 1852, in reference to a tall pine tree in the center of the village. Originally timberland, the area developed partly due to the construction of the Green Lane and Goshenhoppen Turnpike.

Shown here is the "New Goshenhoppen Reformed Church, East Greenville, Pa." This church bears an original tablet stating that the congregation was founded between 1690 and 1700. The New Goshenhoppen Church cemetery dates back to around 1708 and is one of the oldest cemeteries in the Upper Perkiomen Valley.

In this *c.* 1908 view of Main and Bank Streets, the Perkiomen National Bank appears on the left and the Keely House Hotel on the right. The bank was founded in East Greenville in 1874. The building shown here was constructed in 1877 at a cost of $3,400. The hotel had various owners and different names over the years. East Greenville's borough council meetings first took place in 1875, in a second-floor meeting room.

The East Greenville Order of Owls No. 1302 was founded in 1910 with a small membership. In 1942, the organization purchased the former East Greenville Hotel (Keely House) at Main and Bank Streets. Renovations at that time made the headquarters comfortable for service club meetings and banquets. By 1981, the Owls had a membership of 1,000.

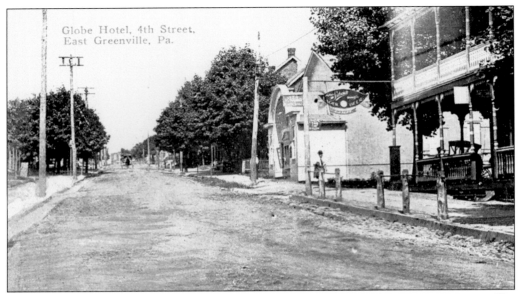

Postmarked December 28, 1912, this card is titled "Globe Hotel, 4th Street, East Greenville, Pa." The hotel shown on the right side was built near the railroad station in 1875. To the left of the hotel is the Palace Theatre, with the arch-shaped front roof. It was built in 1910 and later showed the first motion pictures in the area.

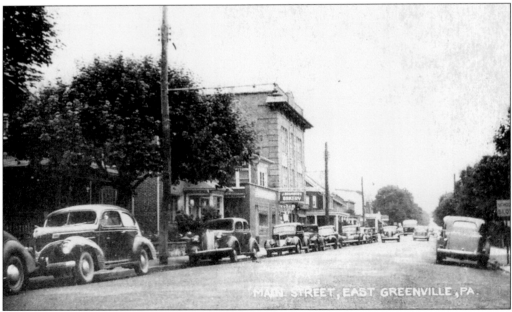

This *c.* 1940s postcard shows a view of "Main Street, East Greenville, Pa." The business in the center of the block is Brunners Bakery, which had been located there since the 1890s, when it was operated by F. W. Kohler. Over the years, the bakery had quite a few different owners.

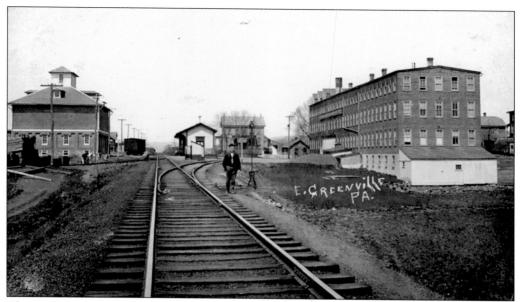

The Perkiomen Railroad Company had reached East Greenville by 1875. Postmarked August 12, 1909, this card shows the wooden station house (center) built to serve passengers and freight. In the early 1900s, as many as eight passenger trains operated daily. Freight service was also active in serving the nearby factories. The large building on the right is the Otto Eisenlohr cigar factory.

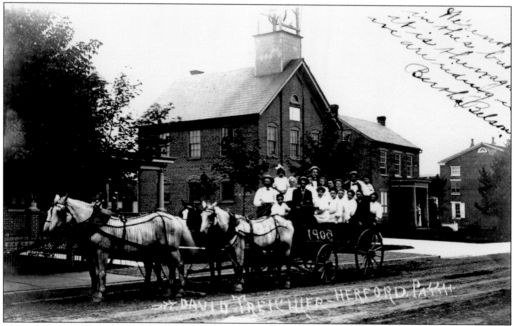

In 1905, this group took a wagon ride and stopped right in front of the East Greenville Fire House, in the 400 block of Main Street. This original fire house was constructed at the dawn of the 20th century and served until a newer fire house was built in 1957. After that time, the original fire house met social and meeting requirements as a borough building.

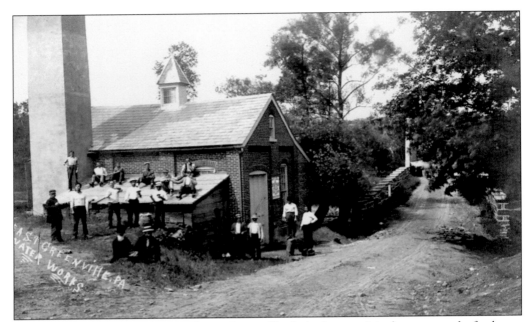

In the late 1800s, the residents of East Greenville desired a municipal water supply for home use and fire protection. It was determined that a water plant would be erected at the Perkiomen Creek, together with a 100-foot-high standpipe for distribution. This standpipe and pump house are seen here about 1907. By 1938, increased population mandated improvements, including a new plant and an additional storage tank.

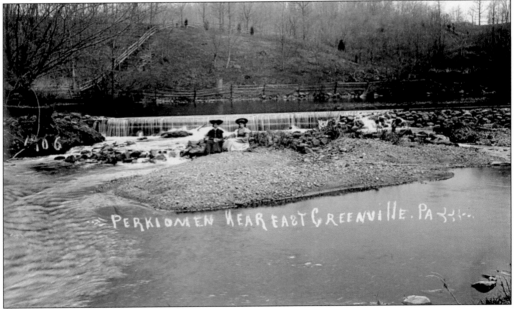

A pair of East Greenville women pose for the camera in 1906. The site was the Perkiomen Creek, in the vicinity of the pumping station. The water falling over the dam provides an interesting backdrop for their quite striking head gear. Considering that the foliage looks like early spring, could these be new Easter bonnets?

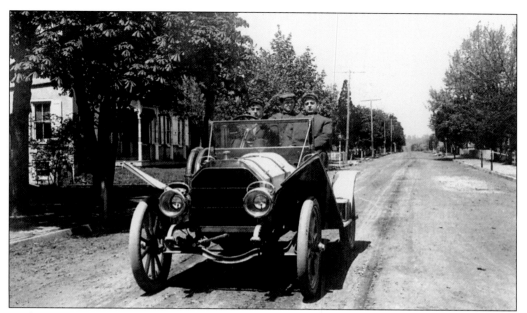

In the early 1900s, East Greenville had a resident photographer who advertised himself as an "Artist in Photography." In this *c.* 1910 postcard view, S. P. Greisamer has recorded a group of East Greenville residents out for a ride in a new Oldsmobile. After 1910, automobiles began to show up on East Greenville streets in increasing numbers.

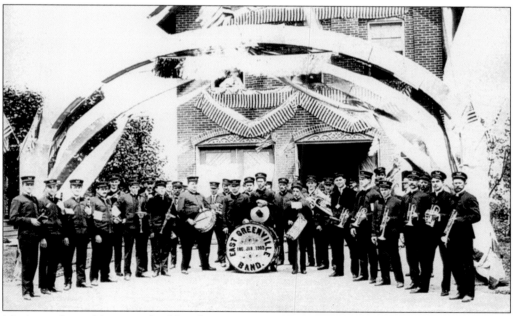

Music performed by organized bands was an important part of the social lives of Perkiomen Valley residents. The East Greenville Band, incorporated in January 1909, played for many different kinds of affairs, including parades and picnics. They also gave the first concert in the New Goshenhoppen Park Band Shell, built in 1923.

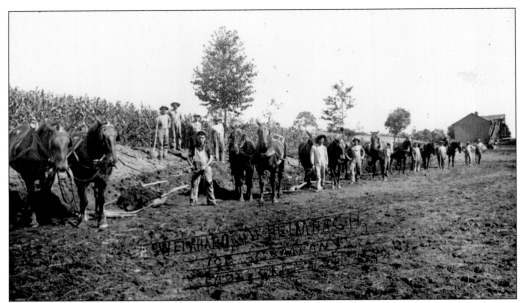

This *c.* 1910 card is titled "Sweinhard and Heimbach Ice Company, East Greenville, Pa." Small armies of teamsters pose on a fair-weather work day, with the icehouse in the background. While the bulk of work in this business was accomplished during the coldest part of the winter, there was activity year round. Maintenance was a never-ending chore, plus stored ice was moved and delivered at most times of the year.

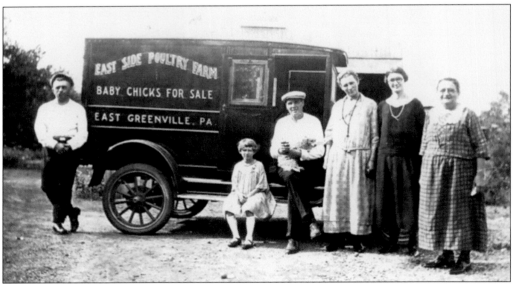

While East Greenville has seen different kinds of industry come and go, many businesses related to agriculture enjoyed longevity. In this classic *c.* 1915 view, family members pose in front of their poultry delivery truck. In addition to serving the folks in the Perkiomen Valley, local poultry products were also sent to the Allentown and Philadelphia markets.

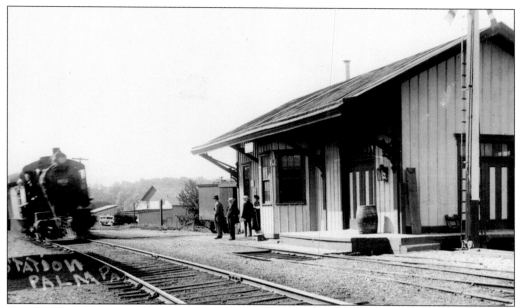

The Perkiomen Railroad station at Palm was of great importance to the local community. There, the railroad company had erected a substantial depot. In this *c.* 1912 postcard view, people await the arrival of a northbound train powered by a steam locomotive. (Courtesy of Roy Miller.)

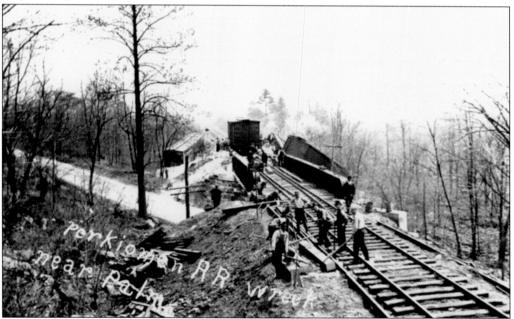

This postcard view is neither dated, nor is the exact location indicated. The photographer labeled it as "Perkiomen R.R. Wreck near Palm." The author speculates that this *c.* 1912 wintry scene actually occurred at the intersection along Gravel Pike. Here, the upright car on the tracks is being filled with what looks like recovered bags of grain. Other maintenance men are repairing ties and track.

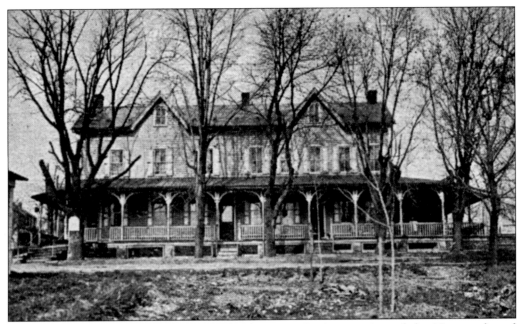

The Palm Hotel was located on Gravel Pike, near the intersection of the Hosensack and Perkiomen Creeks. This *c.* 1909 postcard provides an off-season glimpse of the hotel, which was operated by I. J. Rahn at the time. While the hotel operated as a summer resort for tourists, it also advertised itself as a "good place for Drovers."

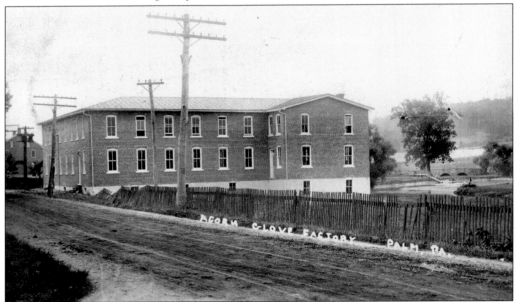

During the first half of the 20th century, Palm had an active glove-manufacturing business. Acorn Glove started in the early 1900s and was successful enough to require a new factory building in 1909. The above view was likely taken after the first addition in 1912. The plant employed more than 100 workers at its peak. Production continued until 1957, when the buildings were converted to warehouses. (Courtesy of Roy Miller.)

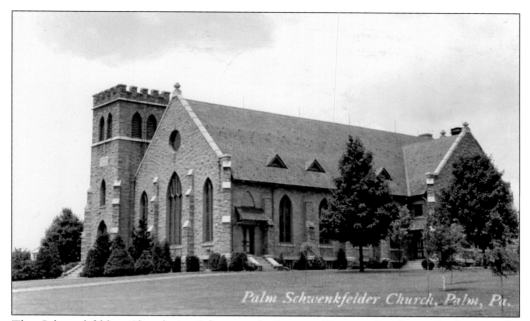

The Schwenkfelder Church in Palm was built to replace outdated meetinghouses. On September 24, 1911, the new church was dedicated. The building included improved Sunday school facilities large enough to accommodate members from three meetinghouse schools that had been built between 1790 and 1815. The Palm Schwenkfelder Church has been modernized several times over the years.

Entitled "Grand Drive, Palm, Pa.," this postcard shows the beautiful Perkiomen Creek and country drive near the village of Palm. The creek has its sources beyond Montgomery County in the Berks, Lehigh, and Bucks areas. In Palm, the size and flow of the Perkiomen is more modest than it is in some of the lower regions. It is, however, powerful enough that it supported several early mills in the area.

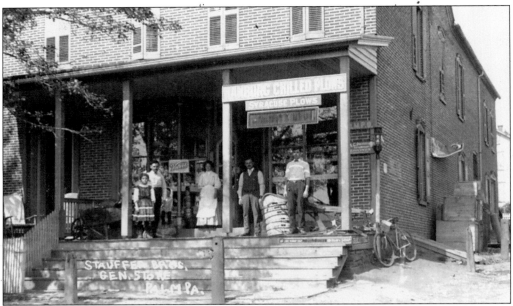

Stauffer Brothers General Store and Post Office in Palm was located a short distance from the railroad station on Gravel Pike. These two views give us an idea of the change in emphasis over nearly a half-century time difference. In the above view, taken about 1907, folks appear on the store's porch surrounded by items for sale. These items include a wooden wheelbarrow, rag rugs, cans of lard, garden rakes, and a horse-drawn plow. Obviously, there was much more inside. Things had changed by the time the card below was postmarked, on July 6, 1956. The signs for veterinary medicines and farm plows are gone. New additions include an Atlantic gasoline pump and various signs promoting the sale of groceries.

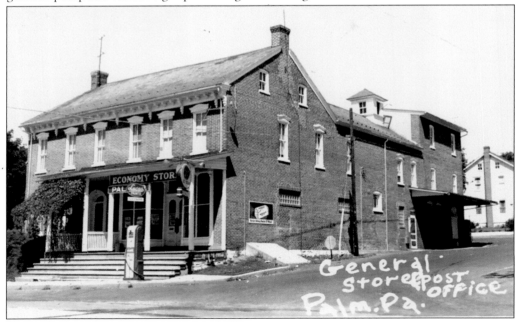